MAY - - 2017

D1400621

Wedding Calligraphy

Wedding Calligraphy

A GUIDE TO
BEAUTIFUL HAND LETTERING

LAURA HOOPER & ALYSSA HOOPER

Laura Hooper Calligraphy

Racehorse Publishing

MORRILL MEMORIAL LIBRARY
NORWOOD, MASS 02062

745.61
Hooper

Copyright © 2017 by Laura Hooper and Alyssa Hooper

All rights reserved. No part of this book may be reproduced in any manner without the express written consent of the publisher, except in the case of brief excerpts in critical reviews or articles. All inquiries should be addressed to Racehorse Publishing, 307 West 36th Street, 11th Floor, New York, NY 10018.

Racehorse Publishing books may be purchased in bulk at special discounts for sales promotion, corporate gifts, fund-raising, or educational purposes. Special editions can also be created to specifications. For details, contact the Special Sales Department, Skyhorse Publishing, 307 West 36th Street, 11th Floor, New York, NY 10018 or info@skyhorsepublishing.com.

Racehorse Publishing™ is a pending trademark of Skyhorse Publishing, Inc.®, a Delaware corporation.

Visit our website at www.skyhorsepublishing.com.

10 9 8 7 6 5 4 3 2 1

Cover design by Michael Short
Cover photograph: Laura Hooper Calligraphy
Interior Photography by Abby Jiu and Anne Kim unless otherwise noted

Print ISBN: 978-1-63158-129-8
Ebook ISBN: 978-1-63158-130-4

Printed in China

Dedication

For our parents, Don and Roxanne Hooper, who have shown endless support throughout this fourteen-year journey and whose encouragement allowed Laura Hooper Calligraphy to grow into the brand it is today.

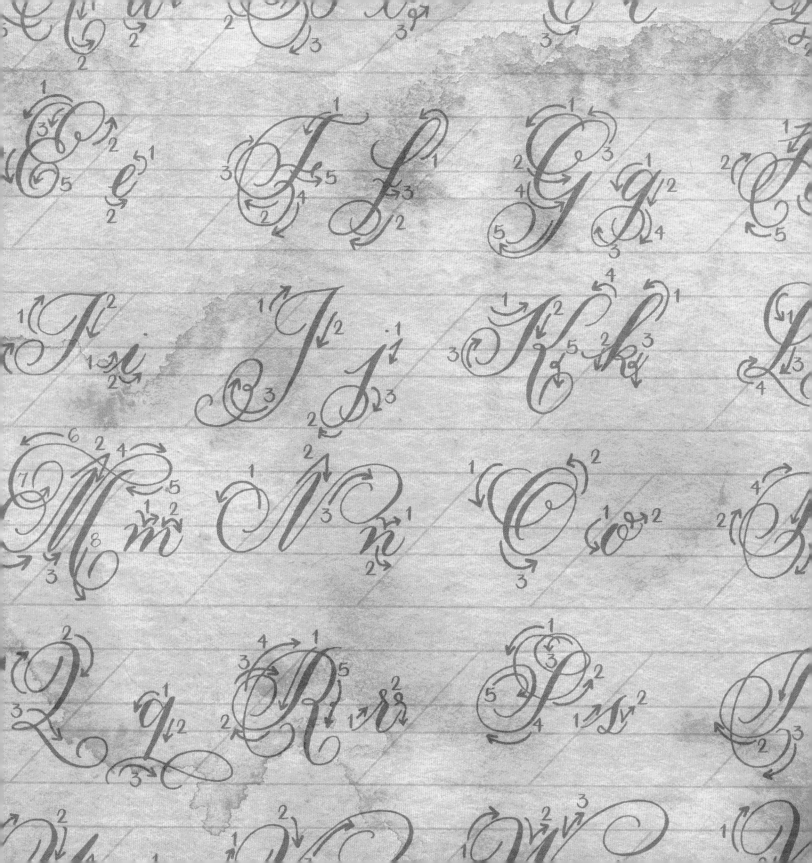

Contents

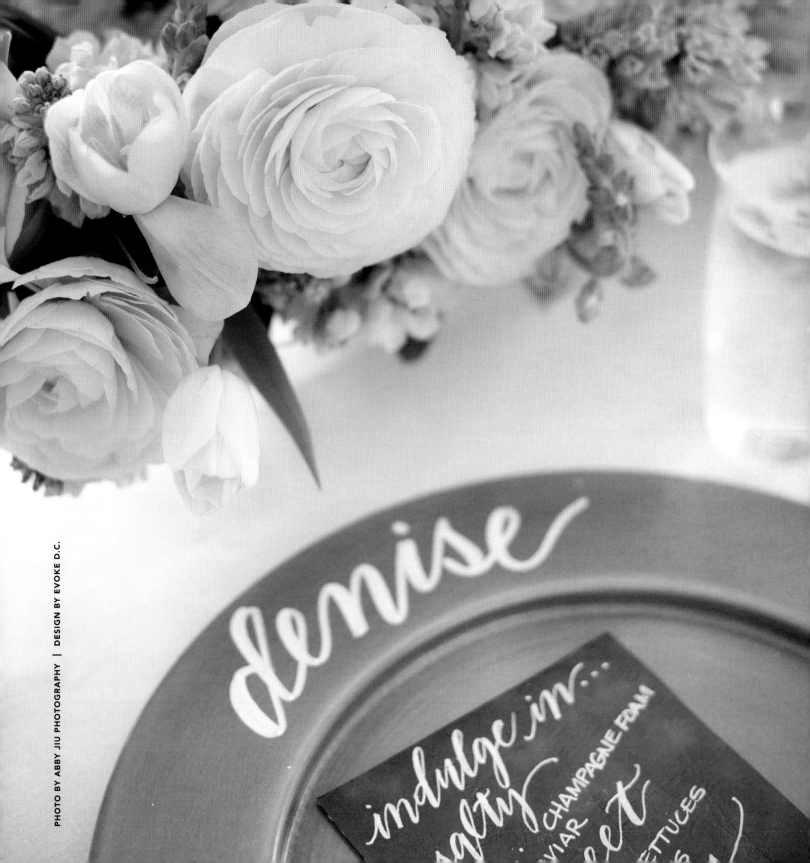

PHOTO BY ABBY JIU PHOTOGRAPHY | DESIGN BY EVOKE D.C.

Foreword

*I*t all began with a single bride.

I was twenty-two years old, and my roommate got engaged. Despite being close, she didn't ask me to be in her bridal party, and I was still young enough to be disappointed by that type of thing. Looking to be involved in some way, I offered to address her invitation envelopes—all two hundred of them—and she graciously accepted.

Once I had addressed the envelopes for my roommate, my dad offered my "services" to a coworker for his daughter's wedding. Soon after, my sister's boss was getting married, so I did her envelopes as well, and this succession of "orders" made me realize that calligraphy could become a career possibility. It all happened so quickly!

I had always considered myself artistic and loved all of my art classes, but after falling short of passing my high school AP Art exam, I had put art on the backburner to earn a BA in business. However, by offering to address my roommate's envelopes—and having no idea what I was getting into—I unknowingly launched Laura Hooper Calligraphy.

Fast-forward to more than a decade later: I have now worked with thousands of clients worldwide on their stationery needs for weddings, show-

ers, events, and more. Laura Hooper Calligraphy has grown to offer not only handwritten services, but also full wedding stationery design and printing; an online shop featuring printed party goods and calligraphy supplies; and education for others looking to learn the art.

Three years ago, my sister Alyssa joined Laura Hooper Calligraphy full-time. In addition to managing part of the business operations, she coteaches calligraphy workshops around the country by my side. In the pages of this book, Alyssa and I share our combined knowledge on the art of wedding calligraphy, and it's been such a joy to work with her on this latest venture.

As for the roommate who didn't ask me to be a bridesmaid in her wedding party, she is now my best friend and there are no hard feelings. In fact, I'll always be grateful she was my very first bride.

Warmly,

Laura

Introduction

Once perceived as an antiquated detail and unnecessary extravagance to many a modern bride, hand-lettered calligraphy is now a highly sought-after aspect of stationery and wedding décor—and with good reason. Wedding stationery offers the first glimpse of the style and level of formality of an event. With the incredible influence of social media and wedding blogs, the art of calligraphy has been catapulted to the forefront of popular wedding details. From classic pointed-pen and contemporary lettering to unique and unusual writing surfaces, there truly is a calligraphy style and application for every potential wedding theme or setting.

This book is meant to serve as a foundation of information and inspiration while you learn the art and develop your skills through in-person workshops, online tutorials, and/or instructional kits. It is also designed to relate to a variety of readers, with each section offering direction or insight that can apply to both a couple getting married and a calligrapher.

First, we help you find the lettering type and style that is appropriate for your—or your client's—event, followed by a walk-through of the traditional and contemporary ways that hand-lettered calligraphy can be applied to weddings. Next, we cover the basic terms, tools, and techniques related to pointed-pen calligraphy, followed by a range of DIY projects for the hands-on bride or professional. Insider tips and suggestions are sprinkled throughout, and a complete glossary of calligraphy terms is offered at the back of the book for easy reference.

Whether you're a bride looking for ideas, a novice aspiring to hand calligraphy or letter your own wedding details, or a professional seeking additional insight, this book has something to offer. And while the direction shared here involves our own style and methods, expect your own personal aesthetic to ultimately shine through. There is no single "right" way to practice the art of modern calligraphy, and the possibilities are virtually endless.

Let's get started!

INTRO TO

practice makes perfect

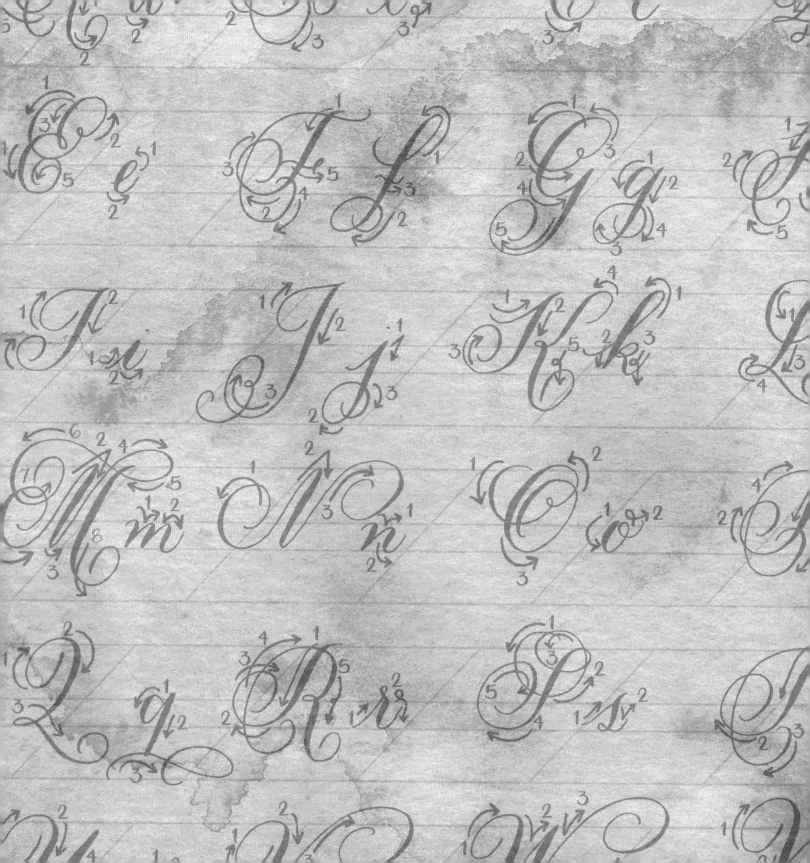

Weddings & Calligraphy

Choosing Your Calligraphic Style or Hand

It's important to understand the nuances of matching the appropriate lettering type and style to a wedding, whether it's your own event or an event to which you've been hired to contribute as a professional. Just as you or your client wouldn't wear black-tie attire to an afternoon garden party, you wouldn't want the category, script, format, or layout of the chosen calligraphy to clash with the tone of the event it represents.

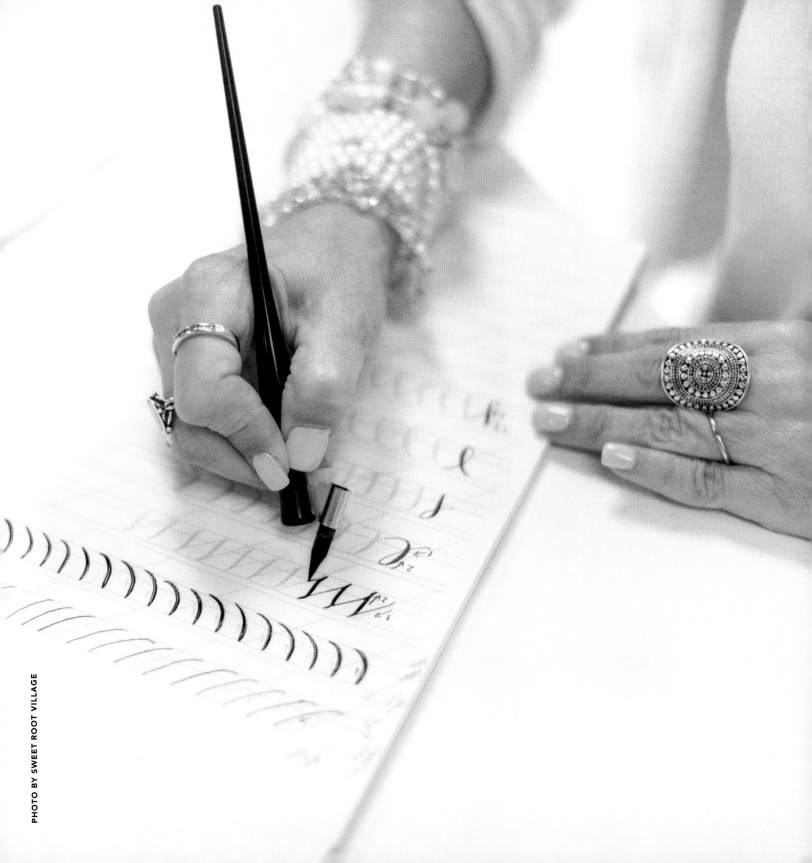

PHOTO BY SWEET ROOT VILLAGE

Categories

There are many different types of calligraphy and lettering that fall within a handful of categories. However, that list could fill an entire book of its own. In the following sections we've selected to pinpoint some generalized, basic differences between the top three styles.

CLASSIC POINTED-PEN

This category includes classic styles such as Copperplate (the Declaration of Independence was written in Copperplate!) and Spencerian. Generally, there are specific letter angles, writing guidelines, and other rules that must be followed with classic pointed-pen calligraphy.

Classic Copperplate Script

Classic Spencerian Script

Classic pointed-pen examples provided courtesy of Master Penwoman Vivian Mungall

These include the commonly recognized characteristic of thick and thin lines.

MODERN POINTED-PEN

Applying the general concepts of classic calligraphy with many of the same tools (dip pen, ink, and nibs), this category invites personal adjustments to develop one's own style. This style also includes the commonly recognized characteristic of thick and thin lines, but they can be written on a larger scale with uneven baselines and other variations.

Modern Beginner

Allegro

Ella

Rosen

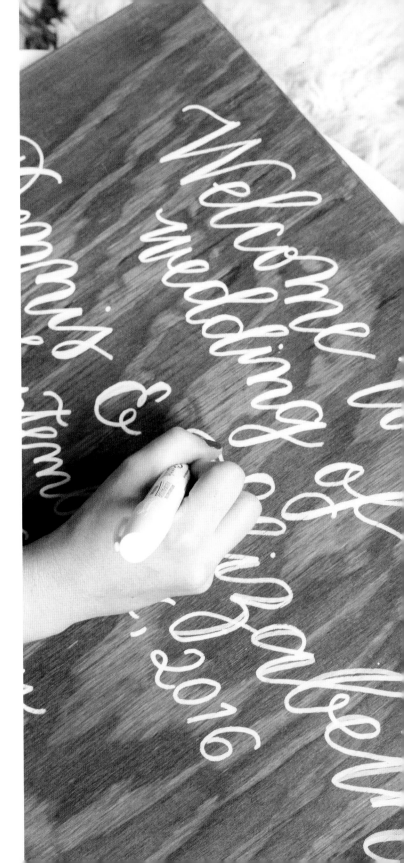

LETTERING

Lettering takes the principles from pointed-pen and applies them to alternate writing tools such as pens, markers, chalk, brushes, and more. It can maintain a monoline style (single line) or shaded (the look of thick and thin). Wood signs, chalkboards, oversized canvases, etc., would most likely be considered lettering as they are not usually created with a dip pen and nib.

Monoline

light and airy

lettering

Scripts

There are countless options for various scripts—many of which are adapted from computer fonts, while others are original scripts dreamt up by individual calligraphers and letterers. On the following pages, we share four of Laura's *exemplars*, or full-sample alphabets, that all fall beneath the modern pointed-pen category described previously. These scripts were selected to demonstrate four different combinations of formal, casual, traditional, and modern styles, all of which can be applied to weddings in their own unique way.

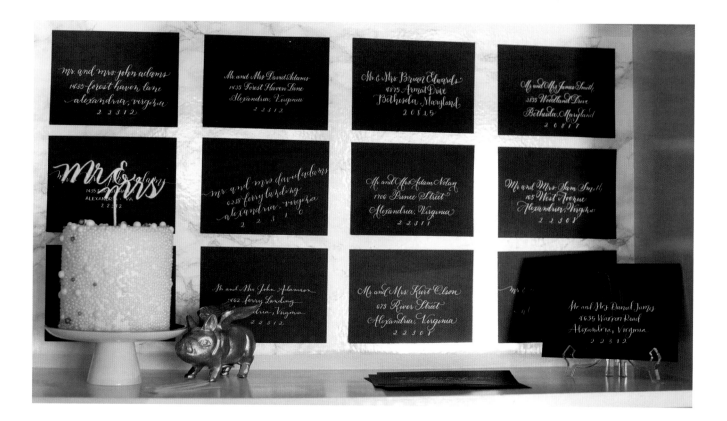

Mr. & Mrs. James Smith
5525 SOUTH STREET
LOS ANGELES, CALIFORNIA
9 · 0 · 0 · 2 · 4

Mr. and Mrs. James Smith
5525 South Street
Los Angeles, California
90024

Mr. Mark Landrevener
10 Boston Avenue
Garden City, New York
11531

Mr. Haley Bickford
PO BOX 3067
YOUNTVILLE, CA
9 4 5 9 9

Mr. and Mrs. James Smith
5525 South Street
Los Angeles, California
9 0 0 2 4

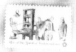

BICKHAM SWASH CAPS

BY LAURA HOOPER CALLIGRAPHY

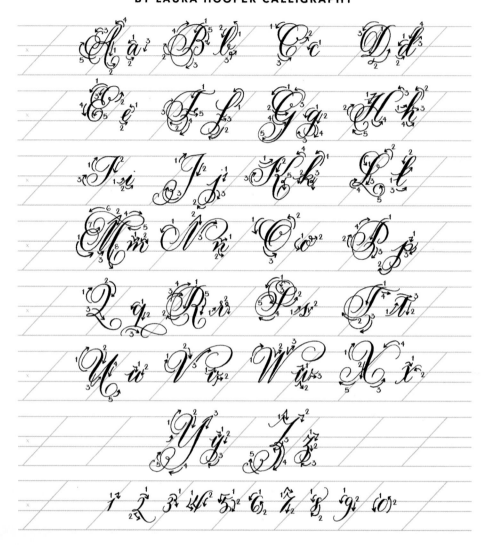

©2017 LAURA HOOPER CALLIGRAPHY INC. | www.lhcalligraphy.com | ⊙ ⨍ ⊙ @lhcalligraphy

FORMAL/TRADITIONAL *Bickham Swash Capitals Script*

This handwritten style is adapted from the computer font *Bickham Script*, which is often used on formal wedding invitations. It features a clean, even baseline with more elaborate flourishing on the capital letters. This script also features a consistent interletter space, a classic feature.

ALEXANDRIA
BY LAURA HOOPER CALLIGRAPHY

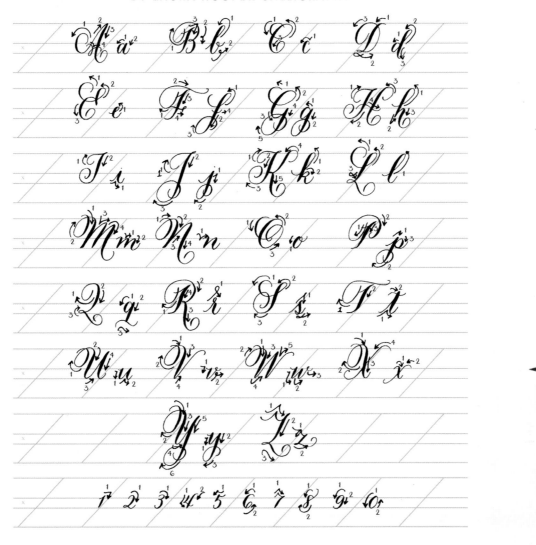

©2017 LAURA HOOPER CALLIGRAPHY INC. | www.lhcalligraphy.com | 🅘 🅕 🅣 @lhcalligraphy

FORMAL/MODERN *Alexandria Script*

Flourished, capital letters combined with a bounced baseline infuses a sense of elegance into a more casual script, while inconsistent interletter space as well as ascenders and descenders of different heights give the script a modern edge.

FRANCINE
BY LAURA HOOPER CALLIGRAPHY

©2017 LAURA HOOPER CALLIGRAPHY INC. | www.lhcalligraphy.com | @lhcalligraphy

CASUAL/TRADITIONAL *Francine Script*

Featuring a return to the even baseline, this script has a more traditional feel, but the delicate flourishing lends a less-formal impression. This script also features a consistent interletter space.

ITALIC
BY LAURA HOOPER CALLIGRAPHY

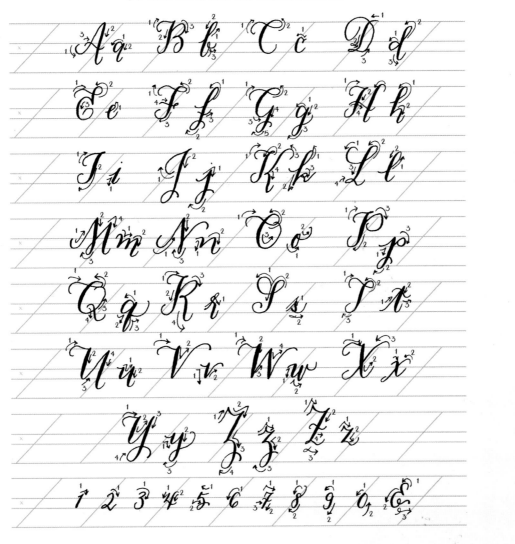

©2017 LAURA HOOPER CALLIGRAPHY INC. | www.lhcalligraphy.com | 🅜 🅕 🅞 @lhcalligraphy

CASUAL/MODERN *Italic Script*

A bounced baseline, loose ligatures, slanted letters, and simple *majuscles* (capital letters) inject this script with a casual, contemporary vibe. Ascenders and descenders of inconsistent heights combined with inconsistent interletter space underscore the relaxed, laid-back feel.

Envelope & Invitation Formats

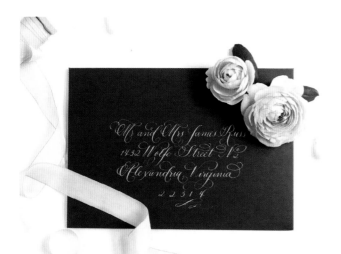

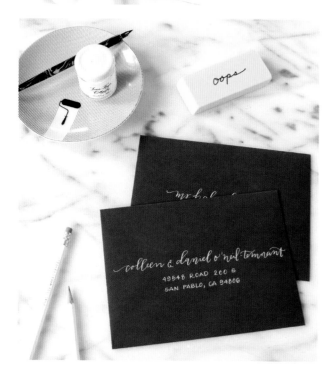

Calligraphy can also be utilized or inserted in varying degrees in order to affect the look and feel of the finished product.

FULL CALLIGRAPHY

Invitations that are created entirely with handwritten script would be considered a full calligraphy suite. While there is a general misconception that full calligraphy may be difficult to read and is only appropriate for black-tie affairs, the legibility can vary greatly depending on the amount of text as well as the script itself.

PARTIAL CALLIGRAPHY

Another format option that incorporates handwritten calligraphy is a mix between a handwritten calligraphy script and a computer font. The computer font is typically some form of capital letters or italicized type, but it's really up to your or your client's personal preference.

TIP!

As a stationer, it's important to remember that you can guide your clients with your expertise (after all, they came to you for a reason and will likely value your input!), but ultimately your job is to execute the wishes of your clients. In today's modern wedding world, we do not use terms such as "always" or "never" when discussing etiquette or "requirements" for wedding invitations and calligraphy.

Together with their families

Marcela Gomes de Matos e Moreno
&
Matthew Steven Hosen

request the pleasure of your company
at their marriage

Saturday, the eighteenth of April
Two thousand fifteen
At half past two in the afternoon

Church of the Good Shepherd
Beverly Hills, California

Please join us following the ceremony
to celebrate the new Mr. and Mrs. Hosen
with cocktails, dinner, and dancing.

The Greystone Mansion & Gardens

905 Loma Vista Drive
Beverly Hills, California

Black Tie

accepts
regrets
number attending

The favor of your reply
is requested by March 30th.

SPOT CALLIGRAPHY

A subcategory of partial calligraphy, this option refers to when a calligrapher and a separate stationer work together, with the calligrapher limited to providing files of key words so the stationer can then lay out the invitation suite for printing. The handwritten components are usually restricted to the names of the wedding couple, the venue(s), portions of the reply card, and headers for any additional inserts (such as accommodation cards, reception cards, itineraries, maps, etc.), so it can sometimes be a more affordable option when working with a stationer. Because it's a version of partial calligraphy, the previous example still applies.

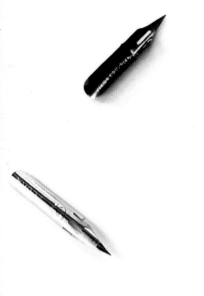

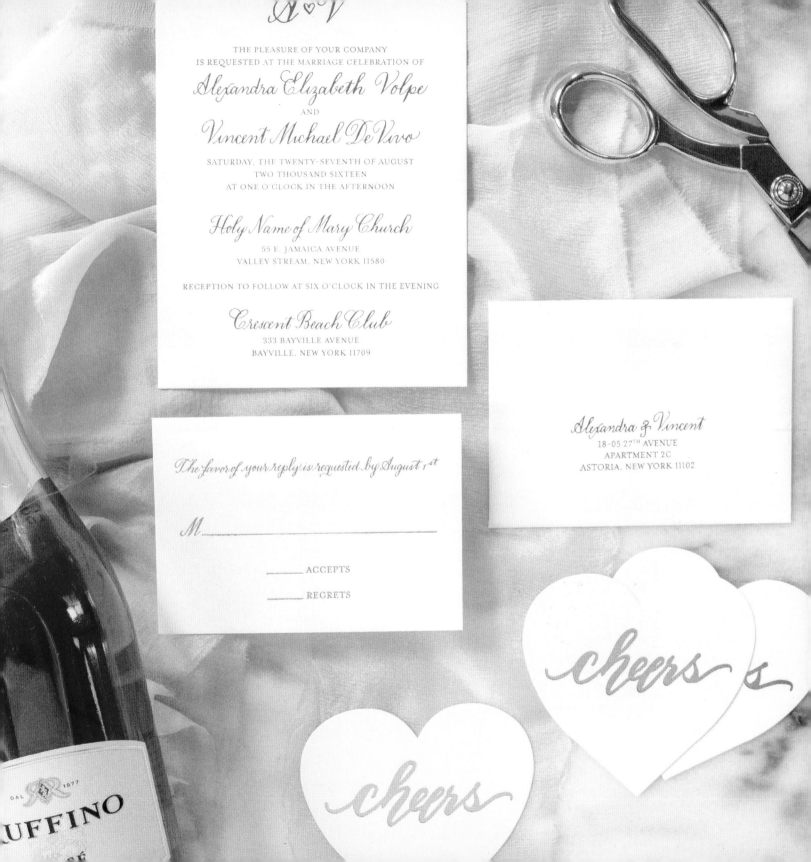

𝒜♥𝒱

THE PLEASURE OF YOUR COMPANY
IS REQUESTED AT THE MARRIAGE CELEBRATION OF

Alexandra Elizabeth Volpe

AND

Vincent Michael DeVivo

SATURDAY, THE TWENTY-SEVENTH OF AUGUST
TWO THOUSAND SIXTEEN
AT ONE O'CLOCK IN THE AFTERNOON

Holy Name of Mary Church

55 E. JAMAICA AVENUE
VALLEY STREAM, NEW YORK 11580

RECEPTION TO FOLLOW AT SIX O'CLOCK IN THE EVENING

Crescent Beach Club

333 BAYVILLE AVENUE
BAYVILLE, NEW YORK 11709

The favor of your reply is requested by August 1st

M_____

_____ ACCEPTS
_____ REGRETS

Alexandra & Vincent
18-05 27TH AVENUE
APARTMENT 2C
ASTORIA, NEW YORK 11102

cheers

cheers

Envelope Layouts

*I*n addition to the style of calligraphy, you can use different envelope layouts to convey the tone of your wedding. On the following pages are several options you can use to imprint the mood for any event—just be sure to accommodate the necessary area for the stamp or stamps. (Vintage stamps have gained popularity in recent years to be used in a collection on envelopes.) We used the same script and address for each of the following examples so you can easily see the differences between the effects.

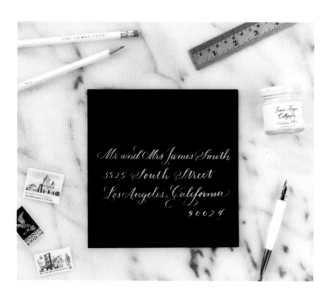

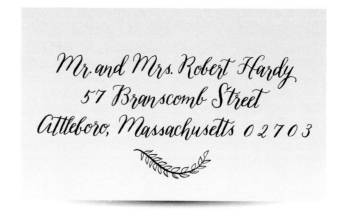

CENTERED

Address block with each line centered on the envelope and in relation to each other.

DECORATIVE

Address block that includes laurel leaves or other embellishments for a more decorative look.

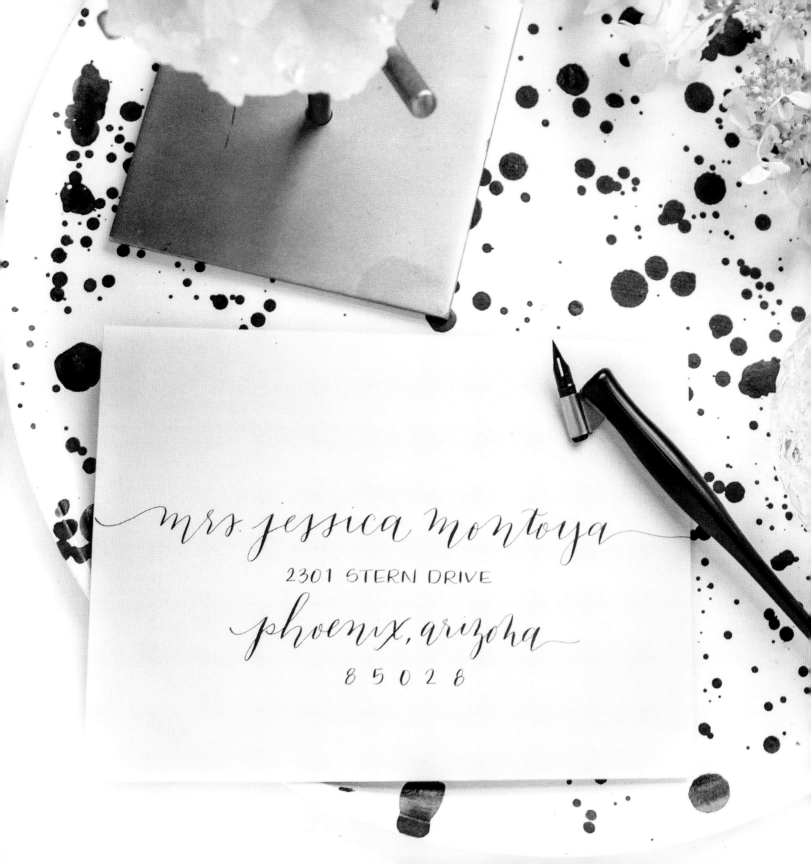

DIAGONAL

Address block that angles towards the upper-right corner.

DROPPED ZIP CODE

Address block with the zip code line "dropped" down to its own line. Can also include a "spread" zip code, which features wider spaces between each number.

Mr and Mrs Sampson Smith
request the pleasure of your company
at the marriage of their daughter

Diane Jane
to
Nicholas Rodney Stewart

Saturday, the sixteenth of May
two thousand fifteen
at five o'clock in the evening

Greenhill Winery & Vineyards
Middleburg, Virginia

to my
beloved

kindly respond by
April 15, 2015
M
____ joyfully will be there to celebrate
____ sadly will toast from afar

Lauren
Hyde

Rebekah
Knoble

kindly deliver to
Mr and Mrs James G Rogers
eight Spain Road
Wayne, Pennsylvania
1 9 0 8 7

Mr. and Mrs. Robert Hardy
57 Branscomb Street
Attleboro, Massachusetts
02703

Mr. and Mrs. Robert Hardy
57 BRANSCOMB STREET
ATTLEBORO, MASSACHUSETTS
02703

FLOURISHING

Address block with extra ornamental flourishes to the script. May or may not exactly match the script of printed collateral inside.

FLOWING BASELINE

Address with one or more lines written on a curved baseline.

Mr. and Mrs. Robert Hardy
57 BRANSCOMB STREET
ATTLEBORO, MASSACHUSETTS
0 2 7 0 3

Mr. and Mrs. Robert Hardy
57 Branscomb Street
Attleboro, Massachusetts
0 2 7 0 3

SCRIPT & CAPS

Address block with a mix of scripts, most commonly a cursive script combined with block letters. Block letters can be crafted with the same pointed-pen nib.

STAGGERED

Address block with each line indented from the previous line to create a staggered effect.

TIP!

If you are including vintage stamps, lay them out on a sample envelope to gauge how far down you need to start the first line of the address block. As a rule of thumb, we usually start about two-and-a-half to three inches from the top with the address block sitting below the center of the invitation. If a planner or client lets us know that vintage stamps will be used, we ask how many inches from the bottom of the stamp they would like us to begin the address block.

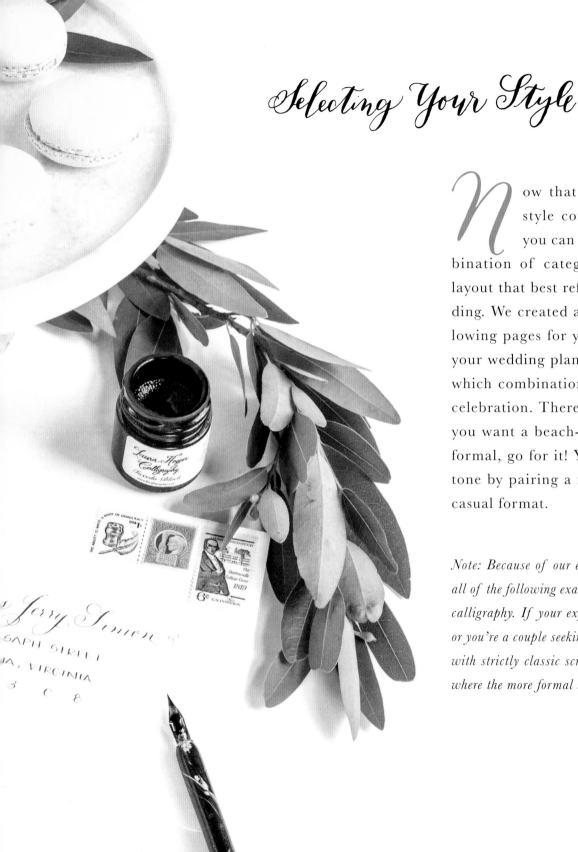

Selecting Your Style

Now that you're familiar with the style components of calligraphy, you can create or suggest the combination of category, script, format, and layout that best reflects the tone of the wedding. We created a few examples on the following pages for your reference, but you or your wedding planner will ultimately decide which combinations will work best for your celebration. There are no hard-set rules—if you want a beach-themed affair to be more formal, go for it! You can exude the desired tone by pairing a formal script with a more casual format.

Note: Because of our expertise in modern pointed-pen, all of the following examples begin with this category of calligraphy. If your expertise is in classic pointed-pen, or you're a couple seeking a calligrapher who's an expert with strictly classic script, it can easily be swapped in where the more formal scripts are used.

BEACH WEDDING

Casual/Modern Script + Partial Calligraphy + Diagonal Format

The enlarged scale and uneven baseline of modern pointed-pen instantly communicates that this is not a traditional wedding, while a loose script on a diagonal with flowing ligatures and block lettering—such as the one shown here—indicates a relaxed vibe. Drop down the zip code to the next line and add a few decorative dots in-between for a fun added touch.

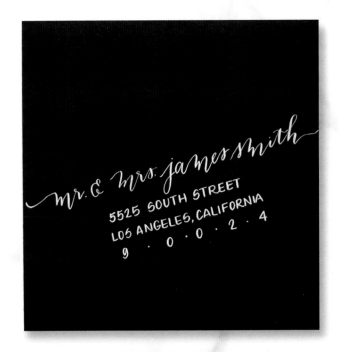

CATHEDRAL WEDDING

Formal/Traditional Script + Full Calligraphy + Centered

A formal script with more flourishes suggests a formal event, so this combination of a highly flourished, traditional script in full calligraphy is indicative of an elegant, formal, black-tie wedding. Oftentimes the added flourishing will make it necessary to drop the zip, so just move it down if you run out of space on the last line of the address.

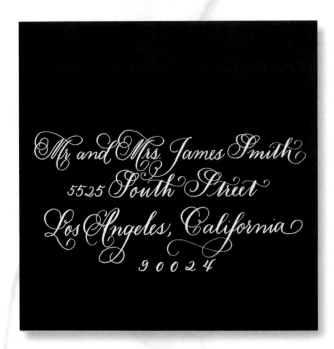

GARDEN WEDDING

Casual/Traditional Script + Full Calligraphy + Decorative

A garden wedding calls for a sense of whimsy and romance, so the oversize letters of a casual/traditional script in a loose-but-controlled, decorative style (or even a diagonal format) work well for this type of wedding. You can drop the zip code to its own line and leave it off-centered to lighten up the more traditional style, and pair with some added loose flourishes to invoke the feel of the garden.

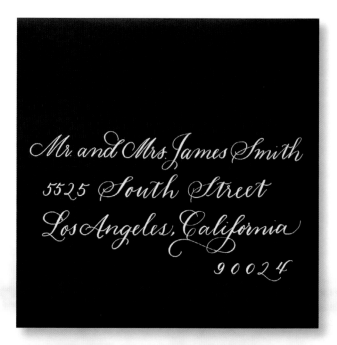

INDUSTRIAL WEDDING

Casual/Modern Script + Partial Calligraphy + Dropped Zip

Typically held in a warehouse or other unique venue (such as a museum), an industrial wedding is a little more modern in style, and therefore lends well to a more contemporary script. Breaking up the script with block letters is also indicative of a modern wedding, while the dropped zip invokes a casual vibe.

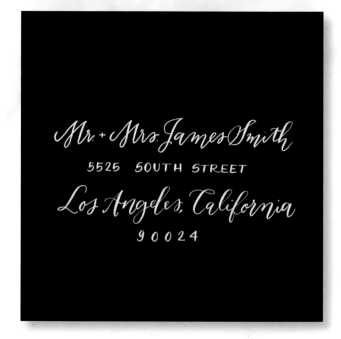

RUSTIC CHIC WEDDING

Formal/Modern Script + Partial Calligraphy + Flowing Baseline

The earthy feel of a rustic, outdoor wedding can be alluded to with flowing calligraphy, which suggests a more casual event. A curved, uneven baseline to add some interest and give the envelopes a playful touch rounds out the vibe. Feel free to even mix a block lettering style in if you wish!

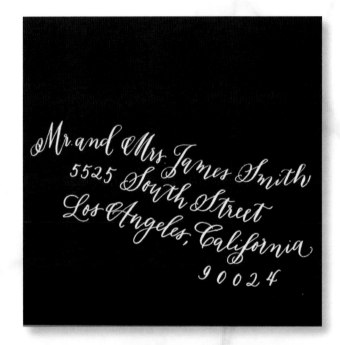

VINEYARD WEDDING

Casual/Traditional Script + Full Calligraphy + Dropped Zip/Decorative

A vineyard wedding can be either modern or feature more rustic, natural elements, so it's a great opportunity to mix some contemporary ideas (such as casual script and decorative embellishments like laurel leaves) into traditional details.

Ultimately, you can use any combination for your special event, but these examples should offer a starting point to determine what will work best for you or your client.

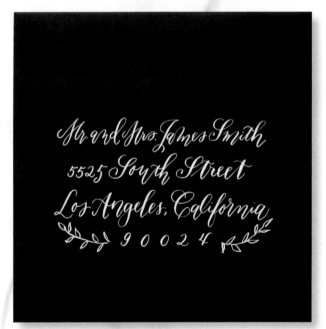

Wedding Calligraphy Applications

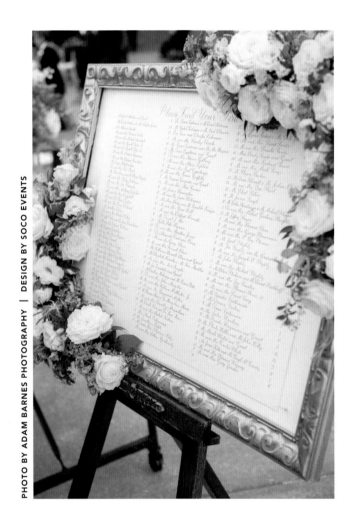

PHOTO BY ADAM BARNES PHOTOGRAPHY | DESIGN BY SOCO EVENTS

Gone are the days when calligraphy was considered an extra invitation detail that was expensive, unnecessary, and maybe even a bit stuffy. Now, there are a variety of wedding-related items to which calligraphy can be applied—beautifully! For our purposes, we will focus on pointed-pen and hand-lettering options, but there are many online tutorials and workshops out there that cover the vast number of calligraphy and lettering styles available today.

Our basic checklist on page 42 gives you a quick rundown of some popular components for wedding calligraphy, followed by detailed descriptions of how you can personalize each so you can expand your imagination beyond the bounds of the inner- and outer-envelope set.

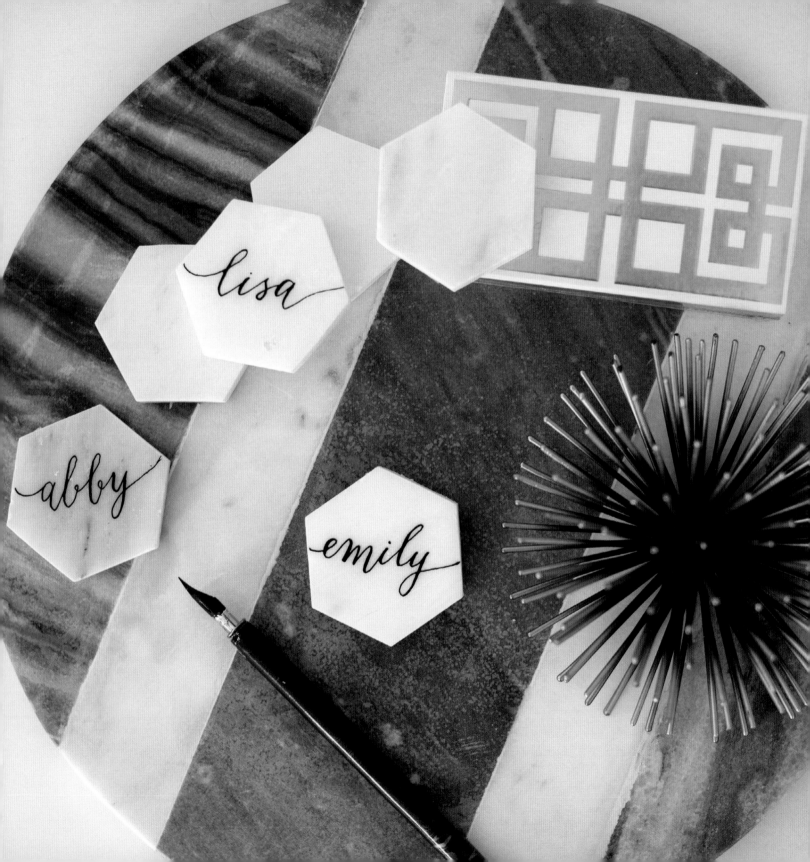

Wedding Calligraphy Checklist

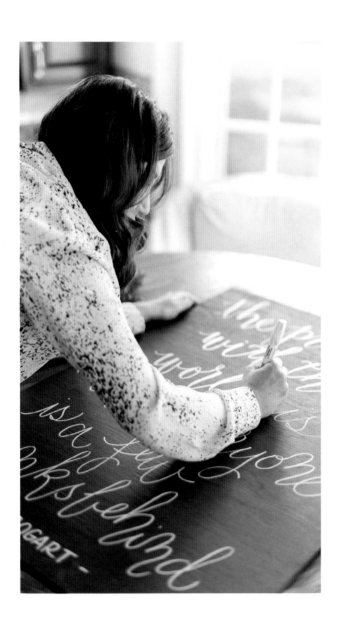

PRE-WEDDING

☑ Save the Dates & Envelopes (optional)

☑ Wedding Invitation Suites & Envelopes

☑ Wedding Party Accents

☑ Welcome Bags

☑ Welcome Signage

CEREMONY

☑ Accessories

☑ Programs

RECEPTION

☑ Favors

☑ Seating (both for escort and place cards)

☑ Signage

Pre-Wedding Applications

SAVE-THE-DATE AND INVITATION CALLIGRAPHY

Calligraphy can be applied to both a save-the-date and an invitation suite following the format guidelines in the first section, with full calligraphy, partial calligraphy, and spot calligraphy. Your preferred calligraphy script, format, and style can be hand-lettered to your liking and then reproduced on paper using digital, letterpress printing, engraving, or other print options.

Note: We do not recommend wedding invitations as a DIY project unless you have graphic design experience and knowledge/access to professional printers. Here we review the possibilities where calligraphy can be included in your wedding planning process and celebration.

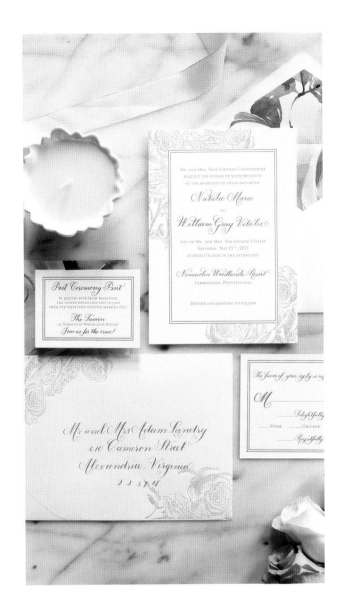

ENVELOPES

Yes, it's a cliché, but envelopes really do provide guests with the first impression of a wedding. Calligraphy is an art form, and handwritten envelopes are so striking that many clients tell us that their guests did not want to throw the invitation envelopes away! It's not every day that people see their names written out so beautifully, and so much about an event can be instantly communicated simply through the script, format, and layout of your chosen calligraphy. You can personalize envelopes even further through color selection, liner style, and paper quality and texture.

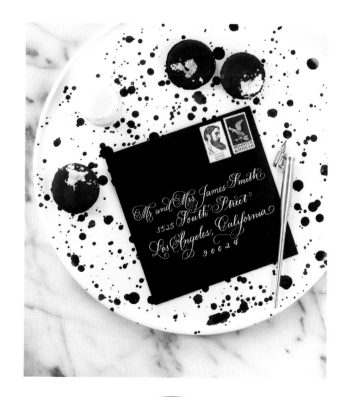

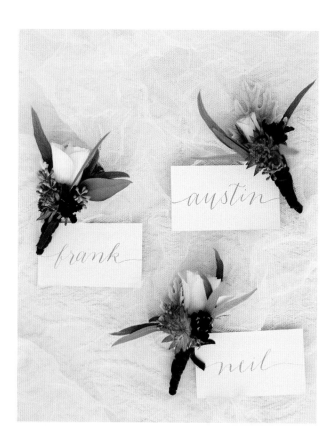

TIP!

When working with your stationer, be sure to ask them to include the return address preprinted on the outer flap of your envelope and on the reply card envelope. Some calligraphers do not offer return addressing, or if they do, it is often the same price as mailing-address calligraphy and can add up very quickly price-wise (because you're essentially doubling the amount of work). If your stationer does not offer this option, you can also consider a custom rubber stamp containing the return address, as many calligraphers do offer this option in the script to match your mailing address script.

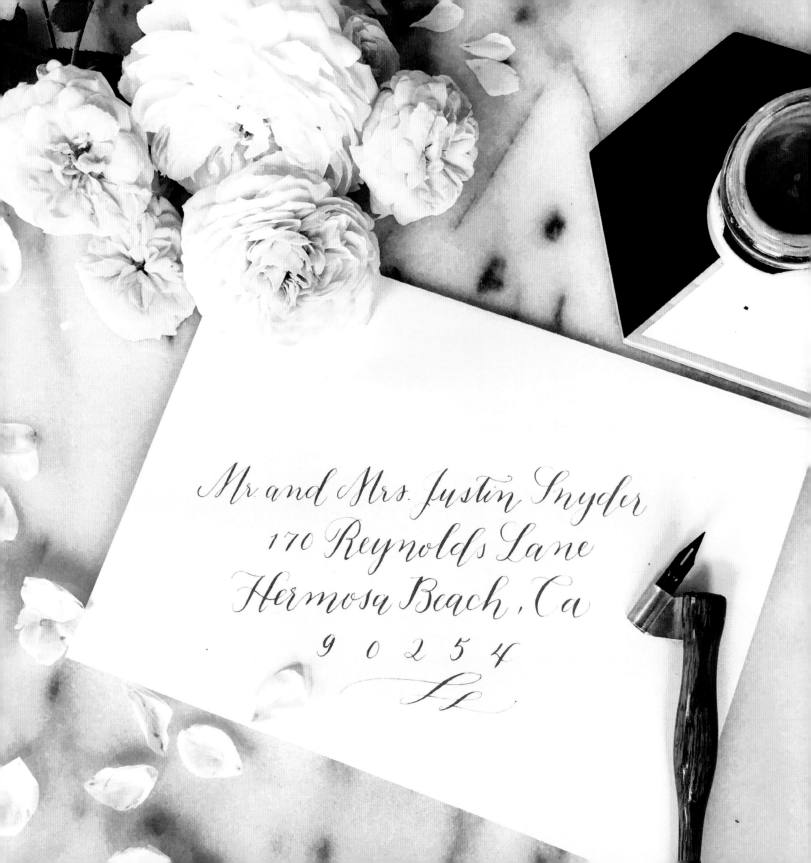

The Future Mr and Mrs
Austin Allen

Ms Lisa Allen

The Future
Mr and Mrs Tyler Austin

TIP!

An inner envelope is a secondary envelope that houses the invitation suite itself (the main invitation, reply card, reply envelope, and any additional cards such as an accommodations card or a reception card), and that set is then inserted into the outer envelope. The inner envelope should not be confused with the reply card envelope, which guests use to return their reply card.

218 East 84th Street
Apartment 5C
New York City, New York 10028

TIP!

Be sure to leave the stamps off of reply card envelopes that are going overseas so the recipient can apply their own country's postage for the return to you.

L

Doctor and Mrs Theodore Tuigen
and
Mr and Mrs Stephen Lenowicz
request the pleasure of your company
at the marriage of their children

Emily Kathryn
and
Matthew Francis

Saturday, the seventeenth of October
two thousand fifteen
at three o'clock in the afternoon

Raphael
Peconic, New York

Reception to immediately follow

The favor of your reply
is requested by September 17th

M _____

_____ accepts with pleasure
_____ declines with regret
_____ will attend farewell brunch

Before we say goodbye
Please join us for a

Farewell Brunch

Sunday, October 18
10:00 a.m. to 12:00 p.m.

The Loft at Harbourfront
43 Front Street
Back Entrance
Greenport, New York

The Future Mr and Mrs Matthew Lenowicz
218 East 84th Street
Apartment 5C
New York City, New York 10028

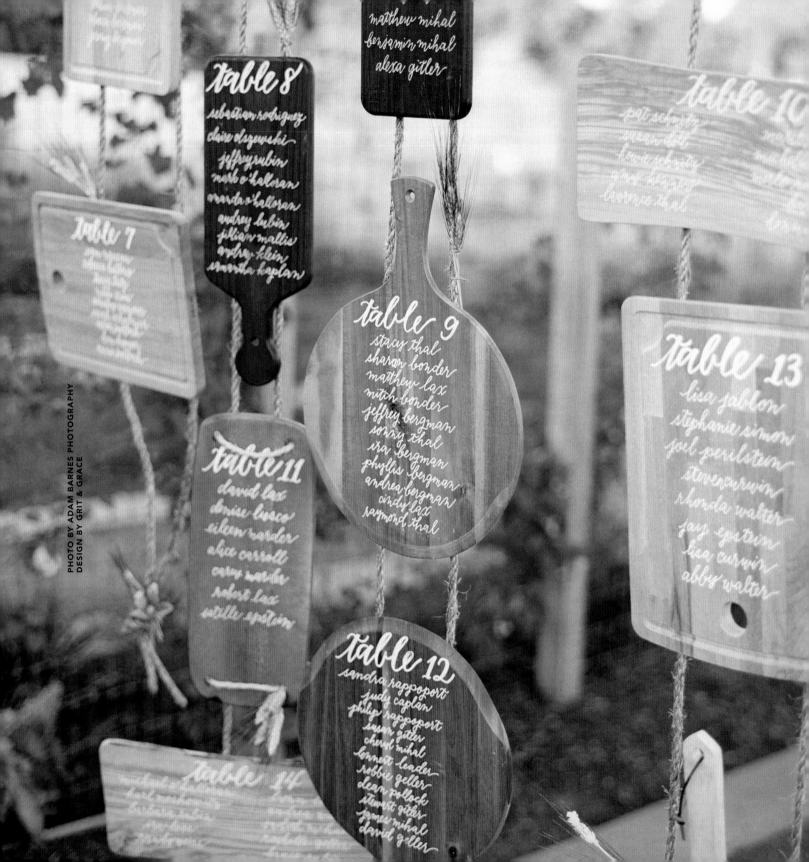

PHOTO BY ADAM BARNES PHOTOGRAPHY
DESIGN BY GRIT & GRACE

table 8
sebastian rodriguez
claire olszewski
jeffrey rubin
mark o'halloran
amanda o'halloran
audrey lubin
jillian mallis
andra klein
samantha kaplan

matthew mihal
benjamin mihal
alexa gitler

table 7

table 10
pati schmitz
susan dell
howie schmitz
greg herzog
lawrence thal

table 9
stacy thal
sharon bonder
matthew lax
mitch bonder
jeffrey bergman
sonny thal
ira bergman
phyllis bergman
andrea bergman
cindy lax
raymond thal

table 13
lisa jablon
stephanie simon
joel perilstein
steven curvin
rhonda walter
jay epstein
lisa curvin
abby walter

table 11
david lax
denise lusco
eileen marder
alice carroll
carey marder
robert lax
estelle epstein

table 12
sandra rappoport
judy caplan
philip rappoport
susan gitler
cheryl mihal
bennett leader
robbie geller
dean pollock
stewart gitler
james mihal
david geller

table 14

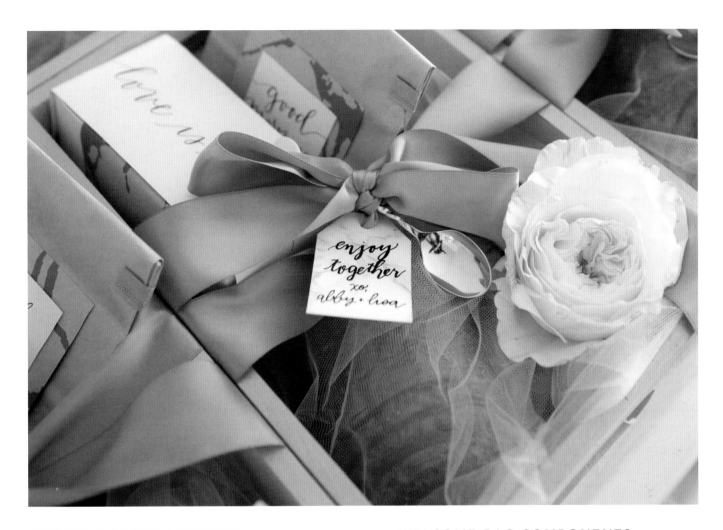

WEDDING PARTY ACCENTS

Even the smallest details look amazing in photos, and the members of your—or your client's—wedding party will appreciate the thought. Wooden hangers personalized with handwritten names for each bridesmaid are a sweet and thoughtful component to add to the "getting ready" session. Name tags for the bouquets belonging to each bridesmaid, flower girl, and maid (or matron) of honor, as well as for the boutonnieres for the groomsmen, ushers, fathers, and grandfathers, are both considerate and photogenic. Be sure to include corsage tags for mothers and grandmothers, too.

WELCOME BAG COMPONENTS

Another place to add a touch of calligraphy to a wedding or an event would be the welcome bags or boxes commonly provided for out-of-town guests. Personalized nametags simply attached to the tote bag or box can go a long way towards making guests feel appreciated, while itineraries or custom maps for the inside of the bags are an easy place to have your stationer insert calligraphic elements that are personal to you.

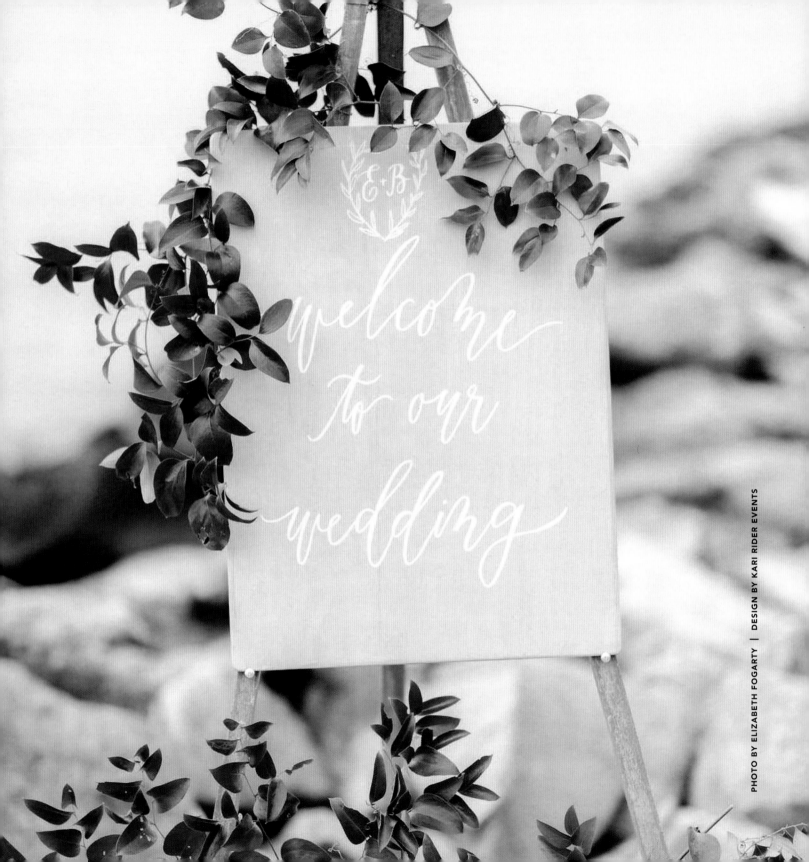

PHOTO BY ELIZABETH FOGARTY | DESIGN BY KARI RIDER EVENTS

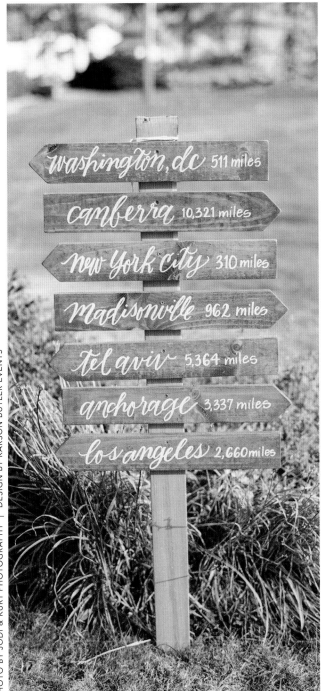

PHOTO BY JODI & KURT PHOTOGRAPHY | DESIGN BY KARSON BUTLER EVENTS

WELCOME SIGNAGE

Welcome signs can be hand-lettered (most commonly on wood boards or digitized for oversized printing as a poster sign) and welcome your guests to your wedding ceremony with some added flare. They most frequently include the couple's names and wedding date, but can also be a simple welcome message.

Ceremony Applications

ACCESSORIES

Calligraphic touches can be added to a variety of areas in your wedding ceremony including "Reserved" signs on seats for VIP guests, signs for the ring bearer and flower girl, custom vow books, hand-lettered ceremony backdrops, and more.

PROGRAMS

Another way to add calligraphy is to coordinate your programs with the rest of your stationery suite. If your program is especially word heavy, you can incorporate spot calligraphy into the printed pieces versus a full calligraphy program that can sometimes be difficult to read. An easy way to do this is to replace each heading with a calligraphy script.

PHOTO BY ABBY JIU PHOTOGRAPHY | DESIGN BY KRUSE & VIEIRA EVENTS

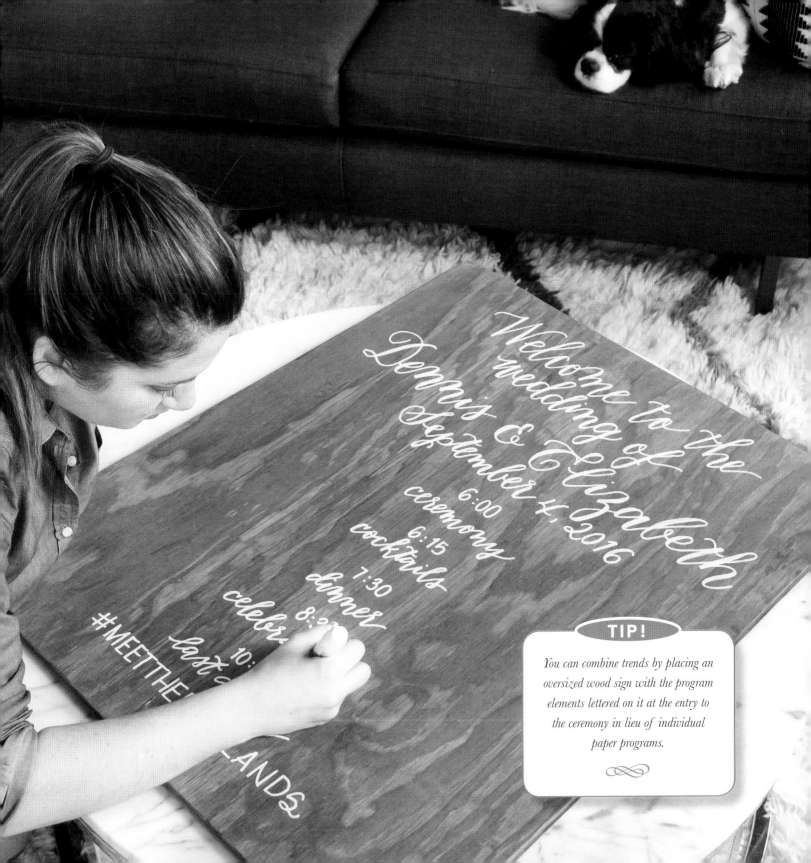

Welcome to the
wedding of
Dennis & Elizabeth
September 4, 2016
6:00
ceremony
6:15
cocktails
7:30
dinner
8:3...
celebr...
10:...
last c...
#MEETTHE...
...ANDS

TIP!

You can combine trends by placing an
oversized wood sign with the program
elements lettered on it at the entry to
the ceremony in lieu of individual
paper programs.

Reception Applications

SEATING

Escort cards and place cards are the common area for calligraphy to be used in reception work, and it's important to understand the difference between the two.

Escort cards tell guests which table they are assigned to. These cards are usually separated by "party," whether it's an individual, a couple, or a family with children under the age of eighteen. Each includes a name or names as well as a table number. Tent cards, mini envelopes with inserts, or flat cards are the most well-known options, but you can also get creative and personalize unconventional items such as rocks, shells, oversize seating boards, and more.

Place cards tell guests which individual place setting is reserved for them at their assigned table. Flat tags, tented cards, or personalized menus are the most common options, but you can be just as creative with place cards as you can with your escort cards.

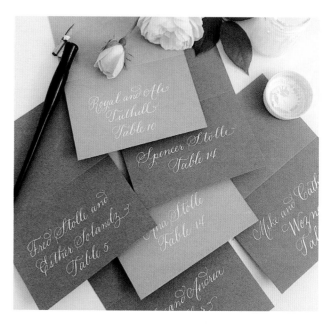

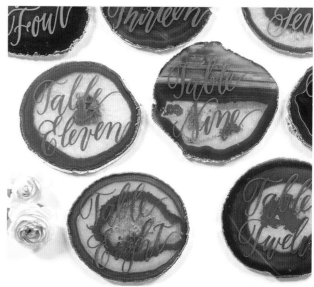

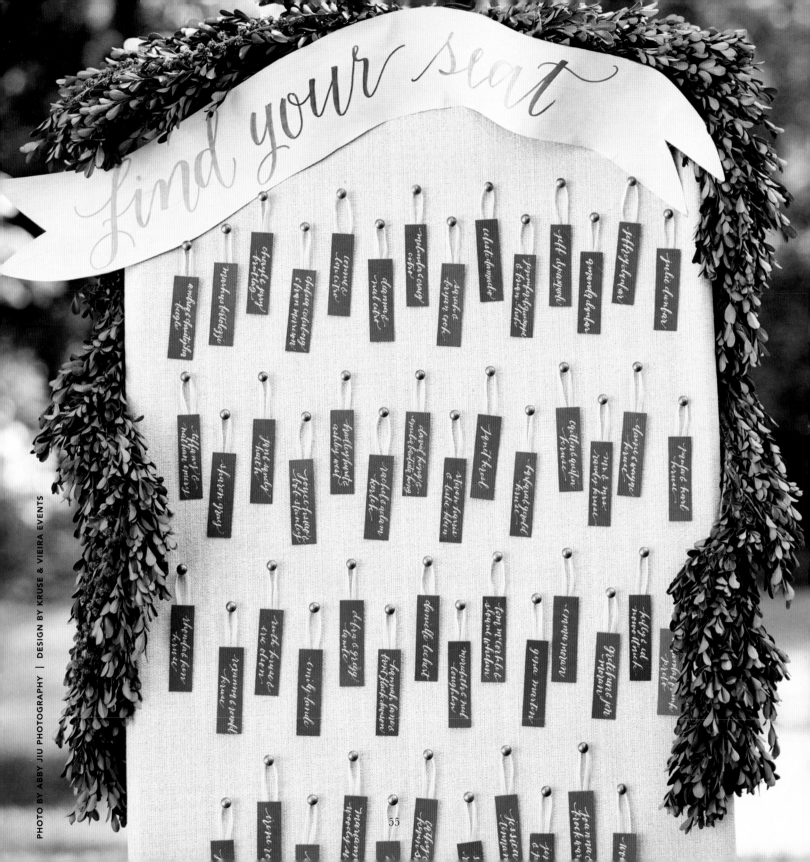

PHOTO BY ABBY JIU PHOTOGRAPHY | DESIGN BY KRUSE & VIEIRA EVENTS

SIGNAGE

Signage is a fantastic way to incorporate personality and style into a wedding. Table numbers go without saying, but hand-lettered signs that welcome guests, offer programs, tag the escort card table, and label displays for favors, food, and desserts, all look great written in calligraphy as well. On a larger scale, you can include oversized signs to direct guests towards the site of the cocktail hour, ceremony, and/or reception. Oversized escort boards are also great conversation starters!

Signage can be done on paper, wood, or unique objects such as slices of agate, bottles, oversized leaves, rocks, or shells. We've even written on life preservers on more than one occasion!

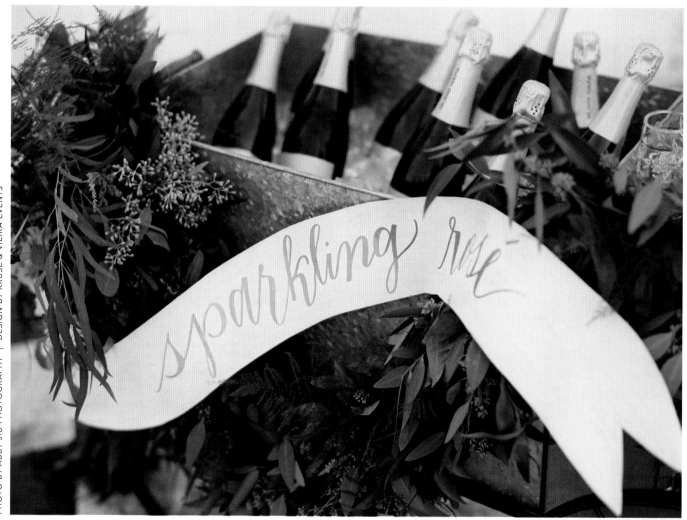

PHOTO BY ABBY JIU PHOTOGRAPHY | DESIGN BY KRUSE & VIERA EVENTS

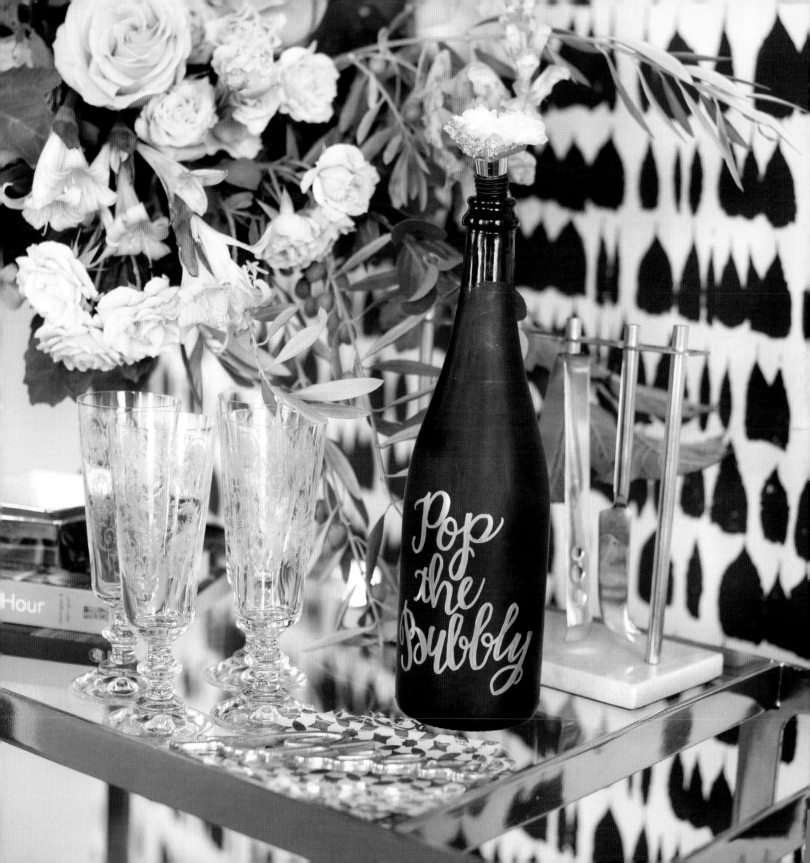

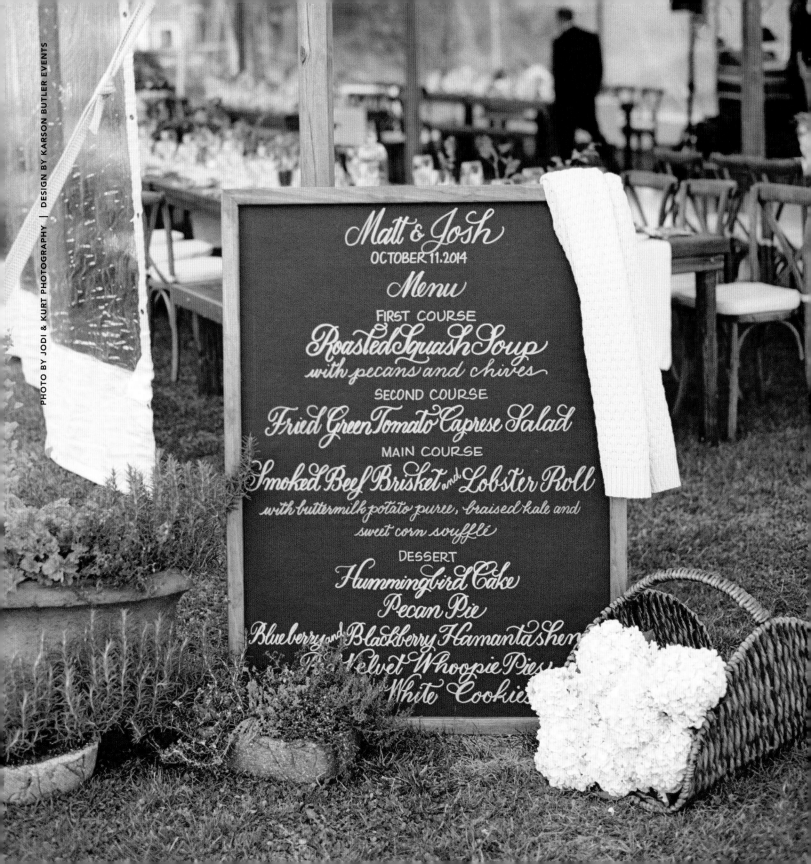

PHOTO BY JODI & KURT PHOTOGRAPHY | DESIGN BY KARSON BUTLER EVENTS

Matt & Josh
OCTOBER 11.2014

Menu

FIRST COURSE
Roasted Squash Soup
with pecans and chives

SECOND COURSE
Fried Green Tomato Caprese Salad

MAIN COURSE
Smoked Beef Brisket and Lobster Roll
with buttermilk potato puree, braised kale and
sweet corn soufflé

DESSERT
Hummingbird Cake
Pecan Pie
Blueberry and Blackberry Hamantashen
Red Velvet Whoopie Pies
White Cookies

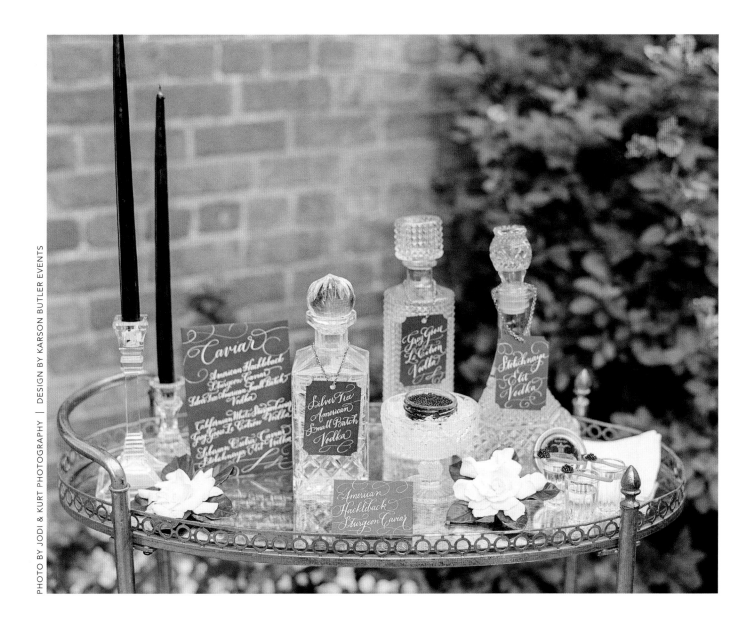

PHOTO BY JODI & KURT PHOTOGRAPHY | DESIGN BY KARSON BUTLER EVENTS

As you can see, there are many creative ways to include calligraphy in your—or your client's—wedding, well beyond just the invitation and envelopes. We hope you'll take all of these ideas into consideration for your event, or let them inspire you to develop exciting options of your own.

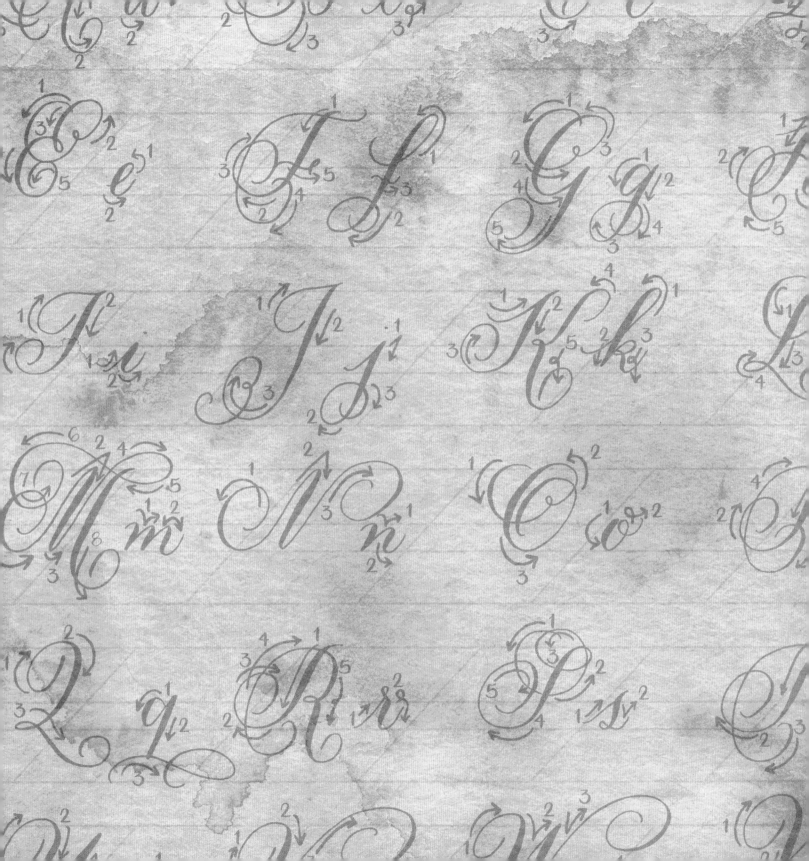

Calligraphy Guidelines & Tips

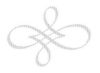

The Basics

Aimed largely at beginners and aspiring DIYers, this section covers basic calligraphy terms and guidelines designed to familiarize you with the art and give you an edge before taking a workshop or other practical instruction (video, etc.). Education is always a good investment, so whether you're reviewing the basics for the first time, opening yourself to another's professional perspective, or learning the lingo before meeting with a prospective stationer, this section can greatly benefit you.

Note: Be sure to reference the complete glossary at the end of the book when needed!

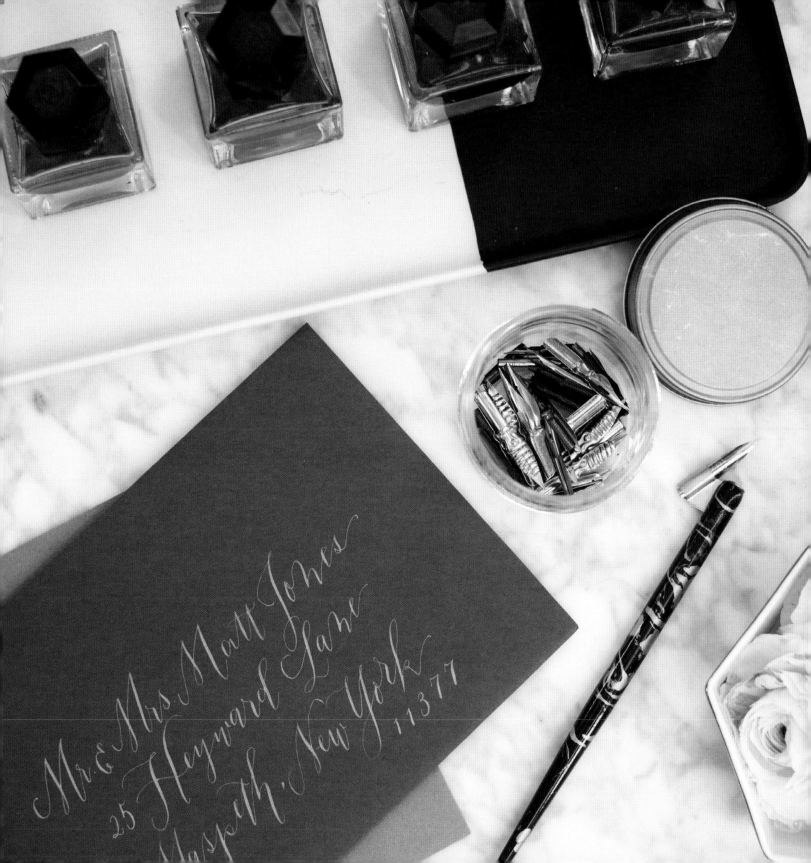

Tools

OBLIQUE CALLIGRAPHY PEN
(Top row, next page)

The oblique calligraphy pen is made up of the long pen holder and the flange protruding from the side to hold the nib. On a right-handed pen, the flange is on the left side as you are holding your pen to the paper. On a left-handed pen, the flange is on the right side. The purpose of the flange is to more naturally achieve the angle necessary to create the thick and thin lines that are characteristic of pointed-pen calligraphy.

STRAIGHT CALLIGRAPHY PEN
(Bottom row, next page)

There is also a straight-pen version available that is sometimes preferred for left-handed calligraphers or when creating ornamental flourishing. When using a straight pen, the nib will be inserted directly into the face of the pen. These pen holders can be used by right-handed calligraphers as well, but the angle of your hand will need to be adjusted so that the tip of the nib is pointing towards the top/top-right area of your writing surface versus off to the left side of your paper.

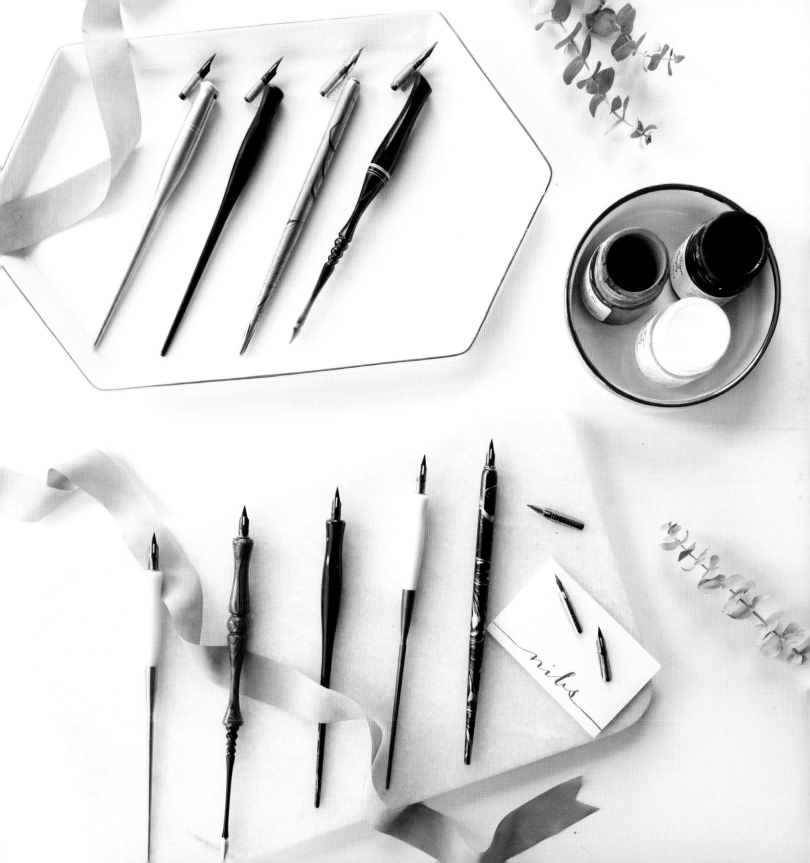

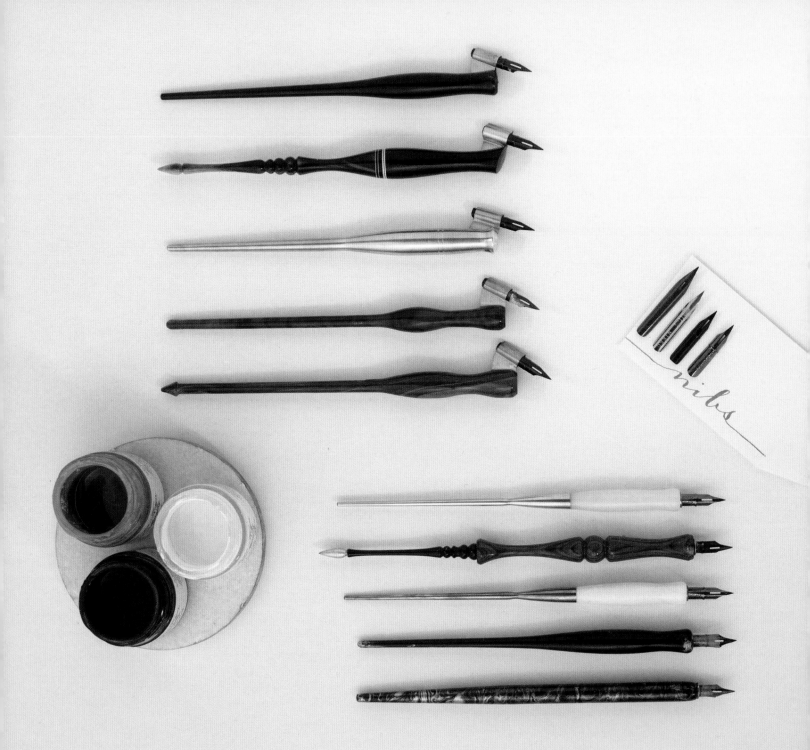

NIB

The nib is inserted into the flange, and is the component that makes contact with the paper when writing. Different nibs are made of different materials, resulting in varying degrees of flexibility. Firmer nibs are recommended for beginners as they learn to gain control over their hand. A more flexible nib allows for the lighter touch needed to create a thick downstroke, but beginners should first practice control over their movements before moving on to more flexible nibs. The top of each nib is stamped with a brand name and a number; some of our preferred nibs for beginners include the Gillott 404, Hunt 56, Hunt 101, and the Nikko G.

The nib is comprised of the body (which is inserted into the flange) and the tip (which touches the surface of the paper). There is a fine slit running towards the vent, which is the open hole. The slit will open to form two tines as you apply heavier pressure on your downstrokes, creating the thick swells of ink. Underneath the vent is the reservoir where the ink sits after you dip. As you write, air passes through the vent, and ink from the reservoir flows through the tines onto your paper.

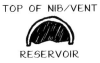

OBLIQUE PEN

FLANGE
HOLDER
NIB

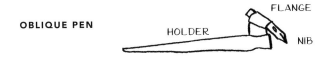

BE SURE SOME OF THE NIB STICKS OUT THE BACK OF THE FLANGE

DIP INK TO HERE

TIP
SLIT
TINES
VENT

FLANGE W/NIB BASE INSERTED

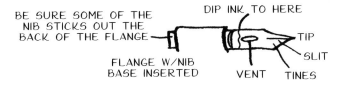

TOP OF NIB/VENT

RESERVOIR

INK

The type of ink that you use can certainly make a difference as well. Different calligraphers have individual preferences, and inks can vary in how they react to the paper you are using. A few of our preferred inks are Ziller, Higgins, Sumi, Walnut, and Dr. Ph. Martin's, but there are many more. You can even create custom ink by mixing Gouache paint with water in small jars. We recommend squeezing a quarter-sized amount of paint into your jar and slowly adding water, mixing and testing until you get to the desired consistency for your project. Ultimately, you will want to have a variety of ink types on hand for testing with any given project.

TIP!

If you find that your ink is bleeding, you can add gum arabic to it to thicken the consistency so it "sits" on the surface of the paper rather than absorbing into the paper and feathering outward. Just make sure you mix it in a separate jar from your original inkwell.

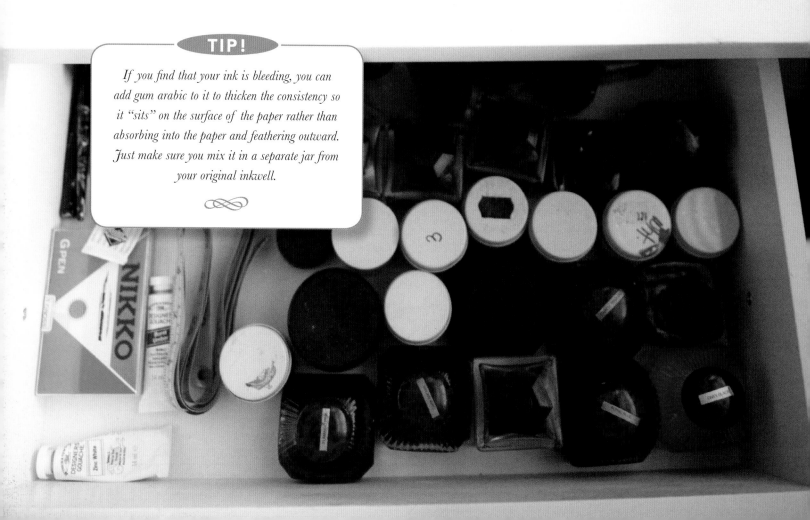

PAPER STOCK

Using high-quality paper is important for practicing your calligraphy. Unfortunately, your standard Xerox copy paper is not a viable option! We recommend paper with cotton in it to avoid bleeding and feathering of ink. There are many calligraphy paper pads available at art stores, but try to avoid options from general craft stores. Rhodia pads and Strathmore marker pads are both common favorites amongst calligraphers.

TIP!

Paper Source and Paper Presentation stores offer a variety of envelopes, as well as flat and folding cards, in a plethora of colors and textures that are appropriate for wedding work.

Tool Preparation

PREPPING THE NIB

When nibs are brand new, they have a coating on them from the manufacturer. The coating is applied to protect the nibs from oxidization or other damage that could occur during shipping, and must be removed prior to use. There are a few methods for accomplishing this, such as running a flame over the nib, but this can affect the flexibility of the metal. You can also lick your nibs, but this tastes about as appetizing as it sounds! We like to dip the nib into our ink—carefully covering the vent, but not touching the flange—and then gently wipe the ink off completely with a soft, clean cloth (or even a basic paper towel) on both the top and undersides of the nib. This can be repeated a couple of times to ensure the coating is fully removed. Another option is to wipe the nib with a Q-tip and toothpaste or rubbing alcohol. You'll know the coating is still present if you attempt to write and the ink beads up on the nib. If that's the case, just dip and wipe the nib again to remove any excess residue.

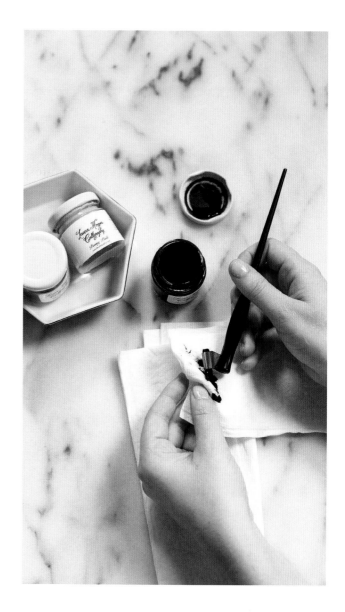

INSERTING THE NIB

To insert your nib, grasp the body of the nib and insert the base into the flange. You'll notice the nib and flange both have the same semicircle shape, so that's what you want to match up. Be sure to push the nib far enough into the flange so that a small portion of the nib sticks out of the back of the flange, unless your flange is not open in the back. Doing this increases leverage on your nib.

FILLING THE NIB WITH INK

When you dip your nib into the ink, be sure to cover the vent with ink. However, don't dip all the way to the flange—and definitely not up to the holder itself. If you are using a straight holder, again, cover the vent fully but do not dip your pen holder into the ink. You want to get enough ink to fill the reservoir, but not so much that the ink is seeping up into your flange and/or pen holder. If you get ink in your flange and/or pen holder, you will have difficulty removing your nib for cleaning. You can also experience ink seeming to "leak" out of the holder onto your hands and projects. There is no cartridge in your pen holder, so the only ink inside is what you put there when dipping.

TIP!

The brass flange and nibs are made of metal, so be sure to handle with care. We recommend removing or replacing your nib with a paper towel or clean cloth to protect your hands.

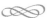

Technique

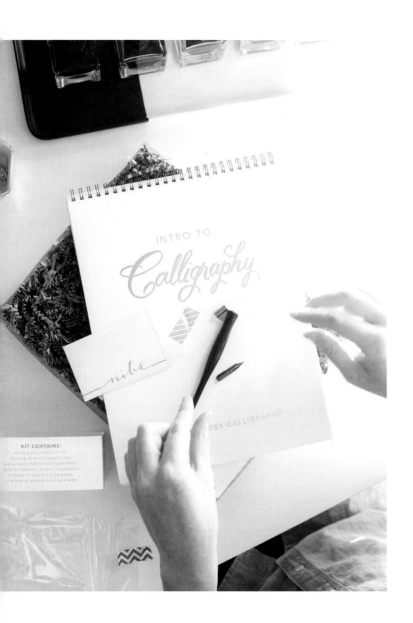

HOLDING YOUR PEN

You want to hold your pen at about a forty-five-degree angle from the surface of the paper to avoid writing on the very tip of your nib. The tip of your nib should be flush against the paper—that is, not rotated onto its inside or outside edge but still pointing toward the top area of your paper. Depending on how angled you would like to be, the tip can point more or less towards the upper-right corner of your paper. Pointing more towards the right corner would lend itself to a more italic-style letter. The reservoir side of the vent should be closer to the paper, with the vent-hole side facing up.

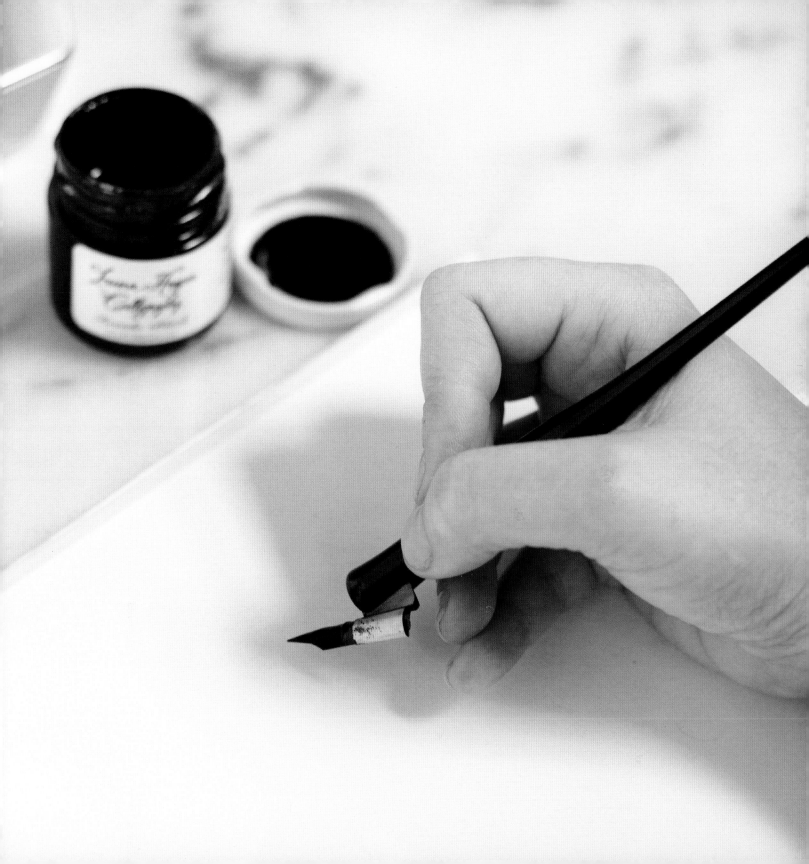

CREATING THICK AND THIN LINES

One of the defining characteristics of pointed-pen calligraphy is the variation of thick and thin lines achieved by changing the amount of pressure on your nib as you write. The thin upstrokes, known as *fine hairlines*, are created with a very delicate touch of upward movement on your paper. The thick downstrokes, known as *heavy swells*, are achieved by applying enough pressure to open the tines of your nib so the ink has a heavier flow.

It is while creating downstrokes that you will most likely notice that your pen has run out of ink. This usually happens after three or four letters. You will see that there are two fine lines, created by your open tines, with nothing between. It will look as if the letters are hollow. This is called *railroading* due to its obvious similarities to railroad tracks. You want to stop as soon as you notice this, redip, and carefully fill in the empty space and continue with your downstroke. There is no backspace in handwritten work, so you want to get used to filling in and continuing on!

If your ink isn't flowing after you just dipped it, it is likely that a small amount has dried on the very tip of your nib, preventing the ink from flowing out. You can gently touch the tip to wet ink to re-moisten the tip area or, if that does not work, you should wipe your nib clean and dip again. You do not want to redip into your ink when you still have ink remaining in the reservoir, as this can lead to too much ink accumulating in your nib and seeping up into your flange.

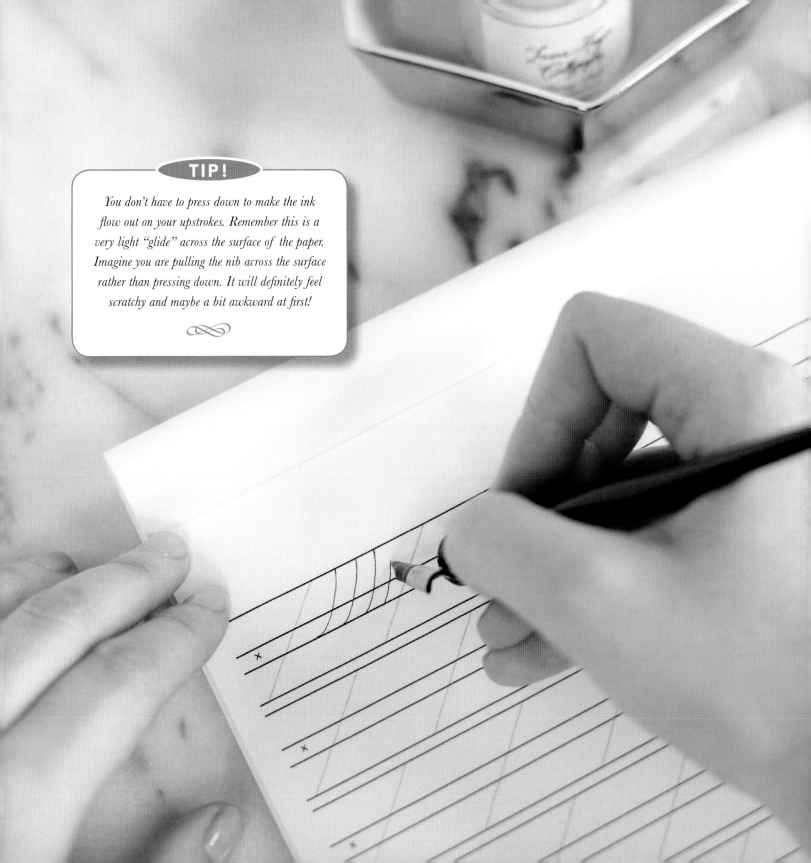

TIP!

You don't have to press down to make the ink flow out on your upstrokes. Remember this is a very light "glide" across the surface of the paper. Imagine you are pulling the nib across the surface rather than pressing down. It will definitely feel scratchy and maybe a bit awkward at first!

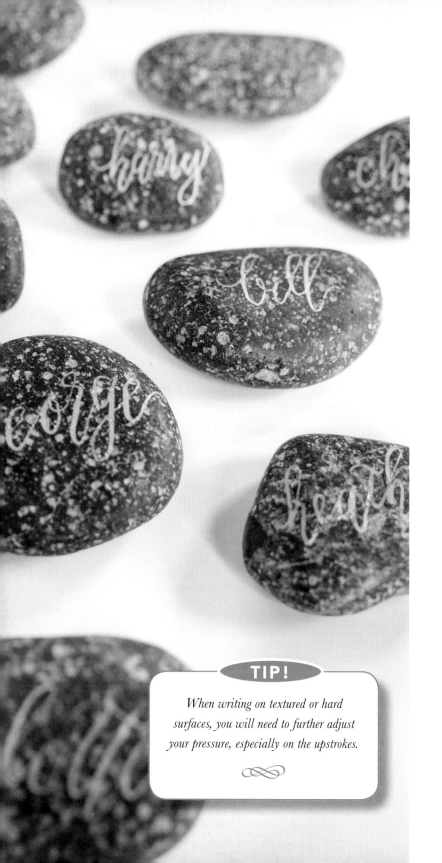

APPLYING THE CORRECT AMOUNT OF PRESSURE

If your nib is digging into the paper, catching and splattering ink, you are most likely applying too much pressure on your upward strokes. You want to delicately glide upwards across the page to achieve a fine hairline for your upstrokes. Envision *pulling* the nib upward, gliding *across* the surface of the paper, versus *pushing* it upwards and *into* the paper. When creating curves and loops especially, you want to be sure you release any heavy pressure before leading into the curve, or your nib can catch and splatter ink.

Additionally, you want to write slowly enough to allow yourself time to actually change the amount of pressure with which you are writing. Generally, you want less pressure for fine upstrokes and more pressure for heavy downstrokes. On your downstrokes, you need to apply enough pressure to literally open the tines on your nib to allow the ink to flow out in a thicker swell. It does not happen automatically—you need to consciously press harder to open the tines.

TIP!

When writing on textured or hard surfaces, you will need to further adjust your pressure, especially on the upstrokes.

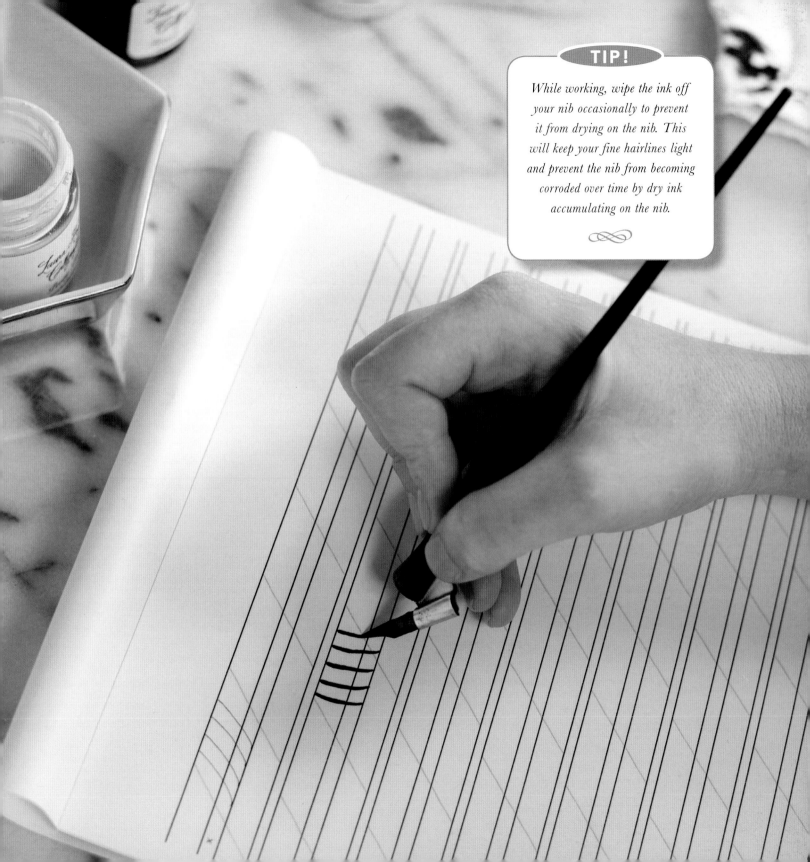

TIP!

*While working, wipe the ink off
your nib occasionally to prevent
it from drying on the nib. This
will keep your fine hairlines light
and prevent the nib from becoming
corroded over time by dry ink
accumulating on the nib.*

Practicing Letterforms

*J*ust as the previous content was not meant to replace in-person or online practical instruction, this subsection of the book is not meant to replace a formal instruction booklet or practice sheets. In other words, don't write on these pages! There are practical starter kits available from a variety of sources that will include everything you need to practice, or you can purchase gridline practice notebooks, alphabet tracing pads, and tracing paper separately.

Depending on the stage you are at with your calligraphy, your own work will vary from what is featured in this book, and that's okay! Whether you are using our guide as inspiration for your own wedding, or the weddings of potential clients, your work should be unique to you. After covering some tips for practicing your calligraphy, we will move into the DIY project applications.

BASIC LETTERING
BY LAURA HOOPER CALLIGRAPHY
1 DRAW YOUR LETTER 2 ADD YOUR THICK LINE 3 FILL BLANK

A A A a a a B B B b b b C C C

Aa Bb Cc

TIP!

If you feel that you have too much ink with each fresh dip, you can wipe the vent side (the top) of your nib across the edge of your ink jar to remove any excess before you begin writing again. Don't wipe the bottom of the nib or you'll remove too much ink and will find yourself redipping more frequently.

Individual Letterform Patterns

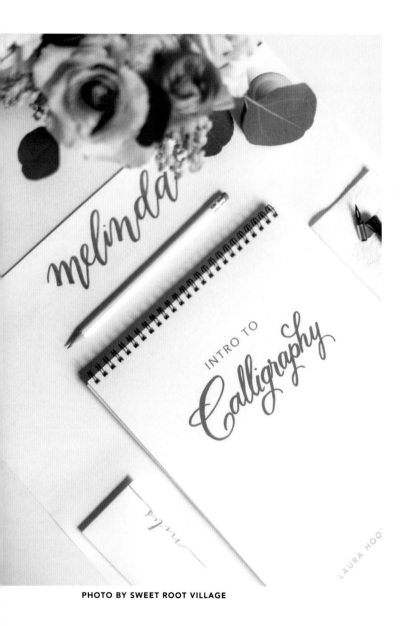

PHOTO BY SWEET ROOT VILLAGE

Pointed-pen calligraphy is a skill that is developed over time, so keep in mind that practice is key. Repeating the same letter over and over is essential to developing the muscle memory in your hand, so while it may seem enticing to jump right into writing sentences, it is important to get a good grasp of each letterform individually before moving on to connecting letters. Do not feel discouraged if it takes some time to develop your skills in calligraphy. For most people it does not come overnight, but rather with years of practice.

When practicing, you want to be sure that you use guidelines of some kind so that you are consistently creating letterforms that are the same size, as consistency is an important aspect of improving the overall look of your calligraphy. Our Laura Hooper Calligraphy practice pads all use gridlines (shown on the next page). Rhodia grid paper is another popular option.

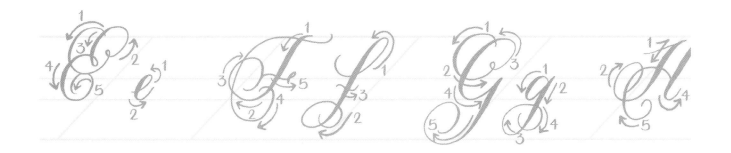

GRID SAMPLE

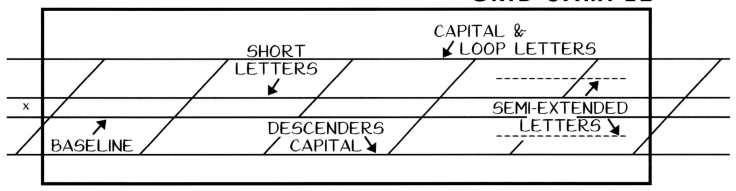

CAPITAL &
LOOP LETTERS

SHORT
LETTERS

SEMI-EXTENDED
LETTERS

x

BASELINE

DESCENDERS
CAPITAL

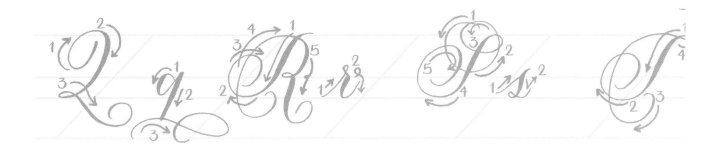

Consistency

"Practice makes perfect" is a well-known cliché, but keep in mind that practice also makes *permanent*. Make sure you are writing your letters correctly—and not ingraining bad habits—by keeping the tips on the next page in mind.

Best Practices Checklist

☑ Make sure the angle of your downstrokes is consistent and parallel. Pick one angle and stick with it throughout your entire project/page:

hello

INCONSISTENT DOWNSTROKES

hello

CONSISTENT DOWNSTROKES

☑ The angle of your upstrokes should be parallel:

how are you

INCONSISTENT UPSTROKES

how are you?

CONSISTENT UPSTROKES

☑ The area between the strokes creating enclosed spaces in letters (a.k.a the counter) should be consistent. All loops and bowls should look as close to the same as possible:

apple jack

INCONSISTENT COUNTER

apple jack

CONSISTENT COUNTER

☑ The space between your letters (the interletter space) should be consistent:

summer Time

INCONSISTENT SPACE

summer Time

CONSISTENT SPACE

☑ Your fine upstrokes (hairlines) should be consistent and the thick downstrokes should be consistent. Where the thick lines taper into thin lines should be the same across all letters in the word or phrase:

onion

INCONSISTENT

onion

CONSISTENT

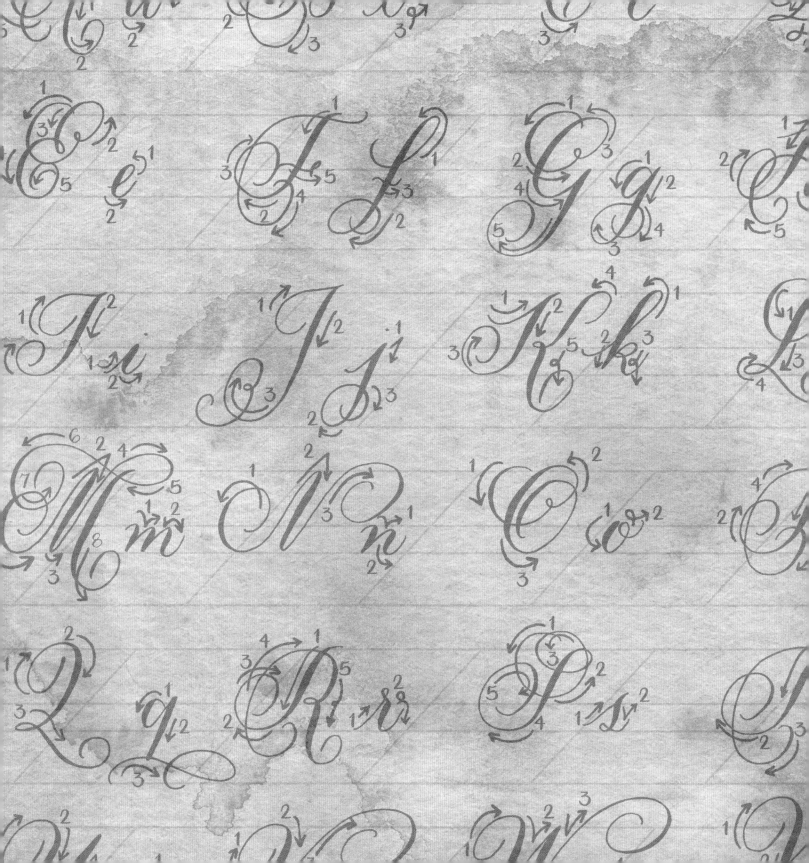

Projects

As shown earlier in the book, there are countless ways you can apply calligraphy to weddings and events in general. In this section, we cover a few of the most popular and unique projects we've had the pleasure of working on over the years. We hope you'll use these step-by-step guides to add texture, an element of surprise, a personal touch, or even a pop of whimsy to make any event festive!

While there are many ways to complete these types of pieces, we've shared the methods that have worked best for us after much trial and error over the years. We hope you'll find them helpful. Feel free to experiment or adjust the materials and steps as needed, basing it on your preference and level of experience. For the sake of consistency, the instructions are written as though the reader does not have tools specific to writing in a straight line. If you do have access to templates or lettering guides of any kind, you can dismiss the steps related to lining and erasing.

Note: When you are ordering supplies to write on, be sure to accommodate for errors and ink testing by ordering at least 15–20 percent overage. So, for a list with 100 names, you would want 115–120 envelopes, cards, etc. On single pieces, such as a wood board, it's best to have at least one extra lined up in the event an unfixable error sneaks in.

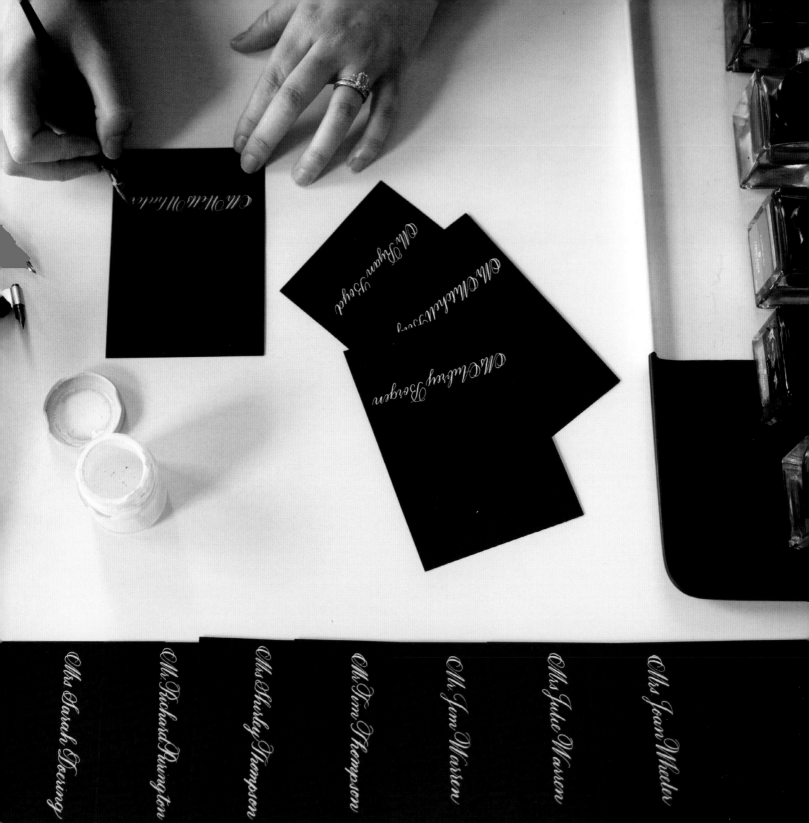

Basic Tented Escort Cards

DIFFICULTY LEVEL: EASY

Adding a simple handwritten card to your wedding décor can instantly elevate the look and experience for your guests. This tutorial can be applied to either flat or tented cards (Paper Source and Paper Presentation are helpful suppliers of ready-made paper goods), and you can even punch small holes in the cardstock to create sweet tags!

Tools needed:

- Ruler
- Light colored pencil or soapstone marker
- Escort tents (standard size folds to 2.5"x 3.5" approximately, but many sizes are available, or you can custom cut your own size with a paper cutter)
- Calligraphy pen, nib, and ink

TIP!

The process is the same for place cards, but without the table number included. Remember: Each guest receives an individual place card, while escort cards are assigned by party.

STEP 1: Pressing down as lightly as possible with a soapstone or light colored pencil (versus a heavy lead one), draw lines on the front of your card. Be sure to evenly space them (two to three lines depending on the length of name and whether or not you would like the table number on the front of the card), and do not apply too much pressure—the more solid/firm your line, the more you have to erase. You only need a faint guide for your straight lines, not a solid line.

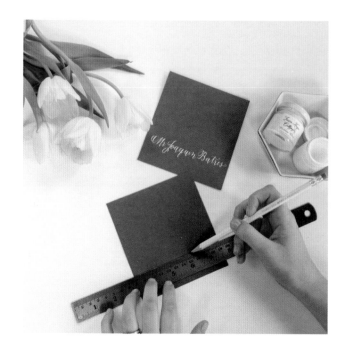

STEP 2: Pencil out the name(s) and table number first if you would like a guide for lettering, and then go over the pencil with the dip pen and ink. The table number can be centered under the name(s), positioned at the bottom-right corner of the card, or even placed on the inside of the tent.

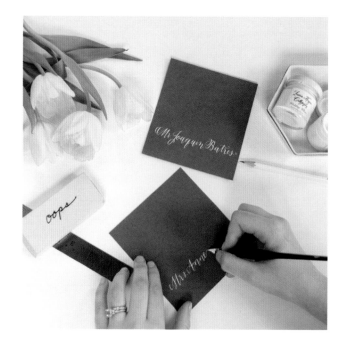

STEP 3: Review your cards against your master list, making sure each name and table number is correct.

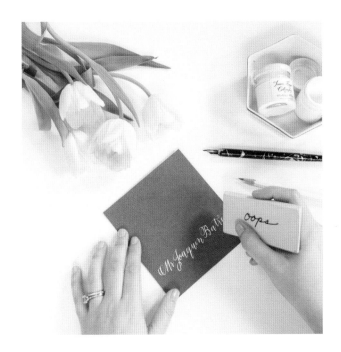

STEP 4: Allow your cards to dry fully, and then erase any lines and penciled lettering that still appears. We recommend waiting *at least* three hours for your ink to dry before you attempt to erase. This step can be completed prior to checking the addresses, but that may result in extra erasing.

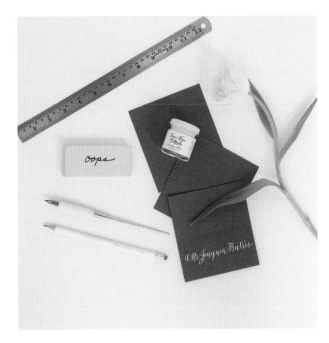

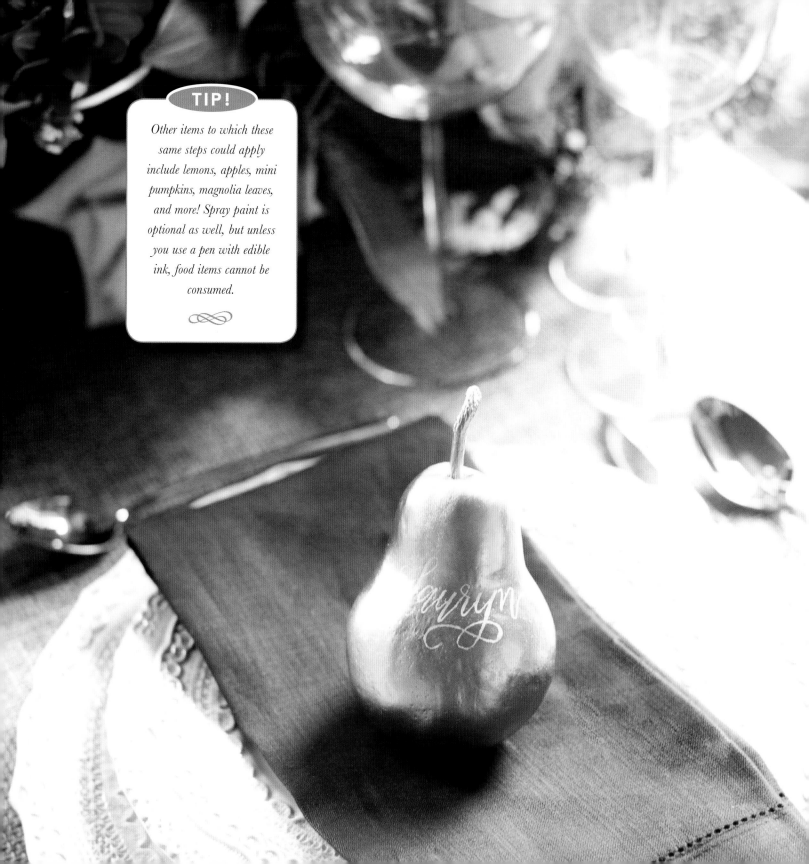

TIP!

Other items to which these same steps could apply include lemons, apples, mini pumpkins, magnolia leaves, and more! Spray paint is optional as well, but unless you use a pen with edible ink, food items cannot be consumed.

Golden Pear Place Cards

Materials for place cards can expand way beyond paper. Pears work well for fall weddings as well as rustic garden fêtes. Unique touches like these can add a pop of whimsy to your overall celebration.

Note: Real pears have a shelf life! You'll want to complete a project like this within a week of the event you're using it for.

Tools needed:

- Pears in desired size
- Gold spray paint
- Fine-point paint pen (we prefer water-based Sharpie paint markers, but there are many other paint-marker options available as well, such as Molotow and Krink)
- Blue painter's tape (optional)

TIP!

Use waxed paper or a wire rack to keep the pears from sticking while the paint dries.

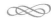

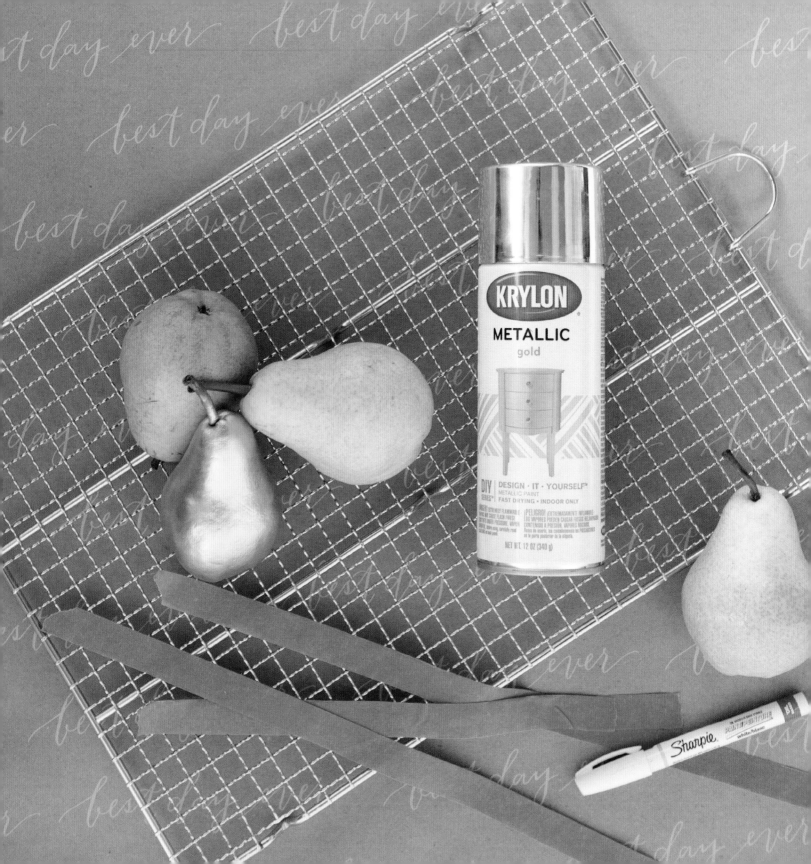

STEP 1: Wash and dry pears to remove any residue that could cause an uneven surface that is not natural to the fruit. Make sure pears are completely dry before proceeding, as paint will not hold if the fruit is still wet when sprayed.

STEP 2: Lay out newspaper, butcher paper, or an old cardboard box as needed to protect your work area.

STEP 3: Once pears are completely dry, hold each by the stem and spray completely around the body, front and back. Set each pear on its bottom to dry.

Note: Once pears are sprayed with paint, they are no longer edible!

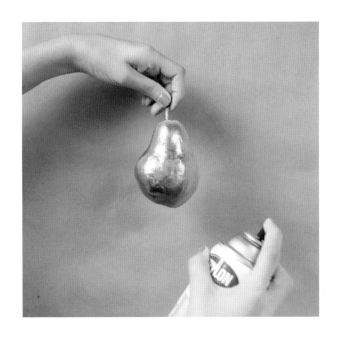

STEP 4: Once the spray paint is fully dry, write each name in a single line with your paint marker. If you need a guideline, use a small strip of painter's tape to provide a removable guide in the writing area.

STEP 5: Fill in where the thicker lines would go in pointed-pen calligraphy. Remember, this is for the downstrokes only! Be sure not to fill in your entry or exit strokes with thickness.

STEP 6: Double-check each pear against your master list.

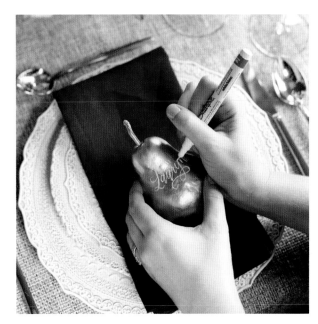

Envelope Lettering

DIFFICULTY LEVEL: MODERATE

Producing a beautifully handwritten envelope may seem like an intimidating goal, but once broken down into individual steps, it can become a much more manageable task! The following pages include the basics of achieving gorgeous envelopes.

Tools needed:

- Light colored pencil
- Ruler
- Calligraphy pen, nib, and ink
- Artist's eraser
- Envelopes

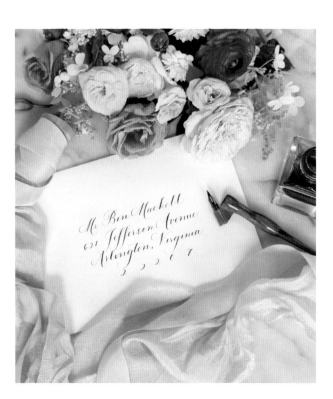

TIP!

Use a high-quality artist's eraser instead of an eraser at the end of a mechanical pencil for an easier process and a cleaner look.

STEP 1: Pressing down as lightly as possible with a lightly colored pencil (versus a heavy lead one), draw lines on the front of your envelope (three lines for a standard address block; four, if you plan to drop your zip codes or to use an address requiring additional lines).

STEP 2: Pencil out the address, and then go over the pencil with your dip pen and ink. Remember that if you run out of ink, you want to stop immediately, redip, fill in the empty area where you ran out of ink, and continue on. (Remember: There is no backspace!) As you address each envelope, set it aside to dry.

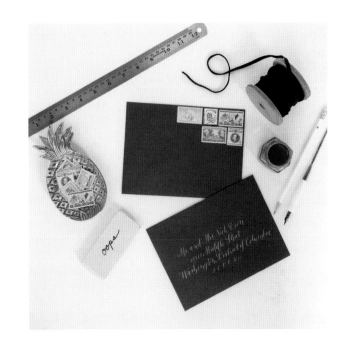

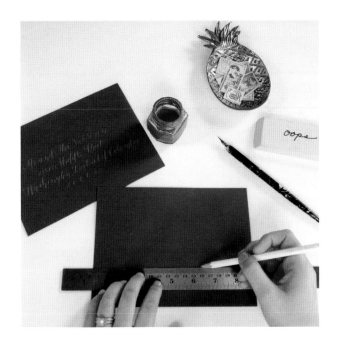

TIP!

To work on your centering, you can perform a mail merge in Word to create label layouts, print them on paper, and use the centered lines to gauge where each line should lay in relation to one another. You can also pencil a vertical line through the center of the your envelope to gauge how many characters should be on each side, making sure to count spaces as characters.

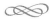

STEP 3: Layer each envelope over the top of the previous envelope, just underneath the bottom line. Start a new row at the beginning once you get to the end of your workspace, as the first envelope in the previous row should be dry at this point. Once you've completed the list, you can gather your envelopes row by row while maintaining most of the original order. (This is just one possible method, but one that we've found works well for us!)

STEP 4: Once the order is complete, we recommend that you go back through and check each envelope against the master list you have printed. You want to check these word by word—in fact, we like to check off each word on the list with a pencil! It can help to have a fresh set of eyes do this proofing for you or, if you must do it yourself, wait until the next day to go through them.

STEP 5: After your envelopes are fully dry, erase the lines you have created. We cannot stress the importance of dry ink enough: You don't want the lettering to smear and have to do an envelope over again. We recommend waiting *at least* three hours for your ink to dry before you attempt to erase. As mentioned previously, this step can be completed prior to checking the addresses, but that may result in extra erasing.

Note: Many calligraphers choose to "seal" their envelope lettering with a fixative in an attempt to avoid damage in the postal system, but ultimately this is an unnecessary step. If your envelope is wet enough to smear your ink, the contents inside are likely already damaged and there are much bigger issues with the invitation inside!

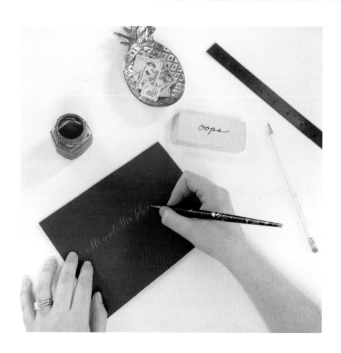

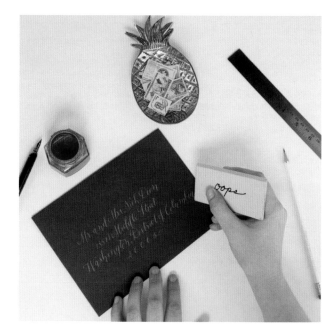

Mr. Mike James
132 Mason Lane
Alexandria, Virginia
2 2 3 0 8

TIP!

*As mentioned previously,
if you or your client intend
to use vintage stamps, be
sure that you start your first
line far enough down from
the top of the envelope to
accommodate them.*

Oyster Shell Seating Cards

DIFFICULTY LEVEL: MODERATE

Want to really impress your guests? Oyster shells are an unexpected touch that can add true "wow" factor to your tables! Shallow, large-size shells work best and can be easily found on Etsy. This project is perfect for beach-inspired celebrations or more formal affairs that happen to be coastal.

Tools needed:

- Oyster shells
- All-purpose spray cleaner and paper towels
- Fine- or extra-fine-point paint pen in a dark color such as black or navy (or gold for a more upscale look)

TIP!

Other items to which these same steps would apply include Spanish tiles, terra-cotta shards, agate slices, and sea glass.

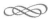

101

STEP 1: Prep each oyster by cleaning the writing area with a paper towel and an all-purpose cleaner such as Windex to remove the sandy grit that naturally resides on the surface of the shell.

STEP 2: Identify the hard, smooth area of the shell's inner surface, which is where you will write. Avoid the calcified area, which is usually softer and matte white in color, as it is difficult for the paint marker to work on that surface.

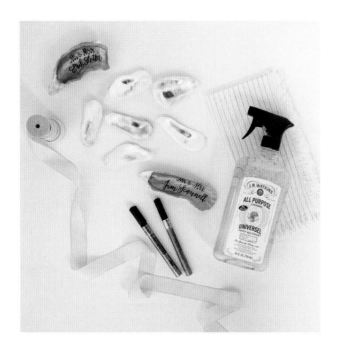

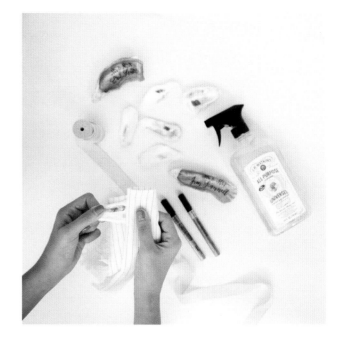

STEP 3: Slowly write each name in a single monoline, remembering that these are real shells and have a naturally uneven surface that will affect the look of your lettering.

STEP 4: Fill in where the thicker lines would appear in pointed-pen calligraphy. Remember, this is for the downstrokes only! Be sure not to fill in your entry or exit strokes with thickness.

STEP 5: Double-check your finished shells for spelling errors against your master list and confirm you've completed them all.

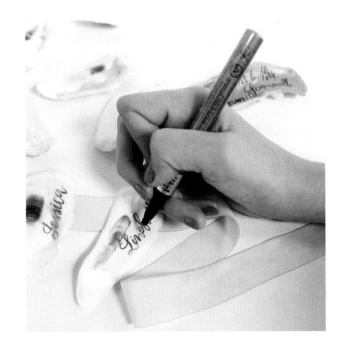

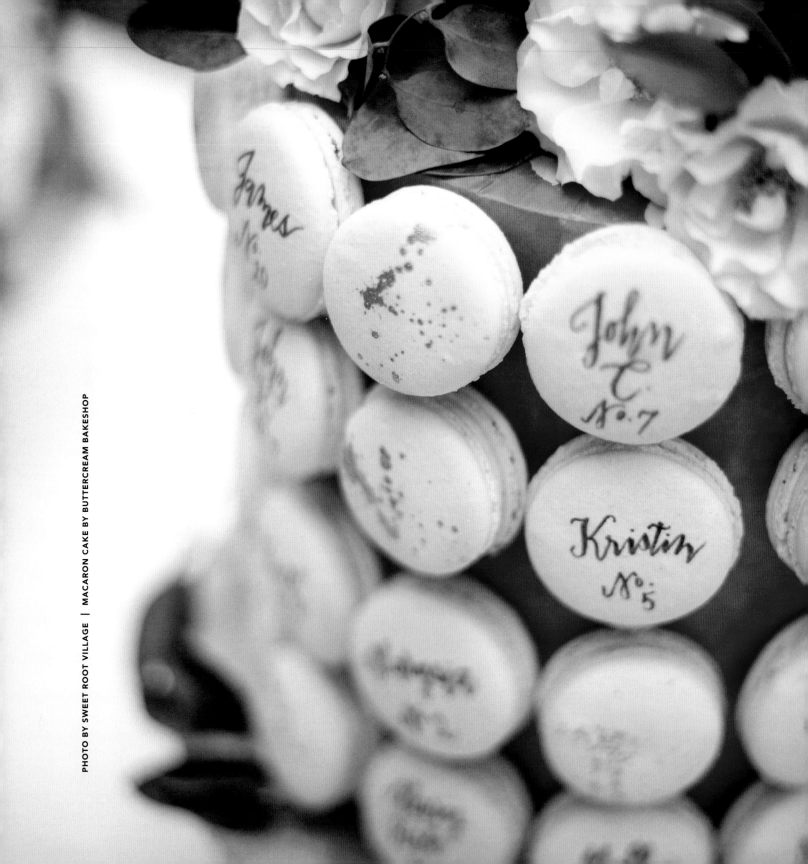

PHOTO BY SWEET ROOT VILLAGE | MACARON CAKE BY BUTTERCREAM BAKESHOP

Macaron Place Cards

DIFFICULTY LEVEL: MODERATE-TO-HARD

Mark your guests' seat assignments with place cards they won't be able to stop talking about (or munchin' on)! It takes just a few steps to turn this trendsetting treat into a wedding detail that won't disappoint. Amazon has an excellent selection of edible-ink pens, and these same project steps can also apply to hard frosting used on sugar cookies, or fondant on cupcakes or wedding cakes.

TIP!

You can turn these place cards into escort cards by adding a table number beneath each name. In this case, we recommend one macaron per person rather than assigning one macaron per party (because, let's be honest, no one will want to share their macarons!).

Tools needed:

- Macarons
- Fine-point, edible-ink pen in desired color
- Latex gloves

CAKE BY BUTTERCREAM BAKESHOP

105

STEP 1: Before handling the macarons, wash hands thoroughly and cover clean hands with gloves.

STEP 2: Pressing lightly so as not to crack the shells, letter each name onto a macaron, eyeballing the centering and straightness of the lines.

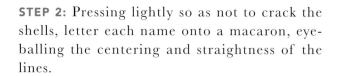

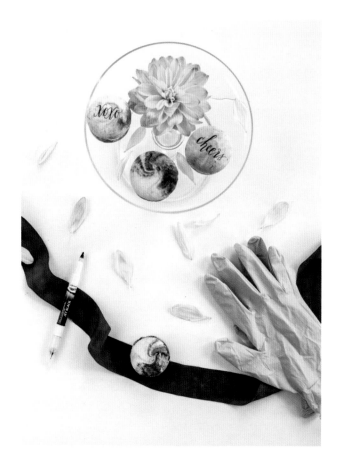

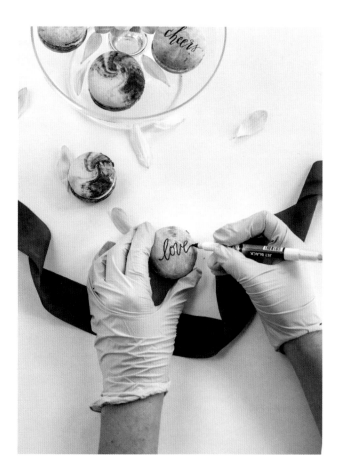

STEP 3: Fill in where the thicker lines would appear in pointed-pen calligraphy. Remember, this is for the downstrokes only! Be careful not to fill in your entry or exit strokes with thickness.

STEP 4: Double-check your finished macarons for spelling errors against your master list and confirm you've completed them all.

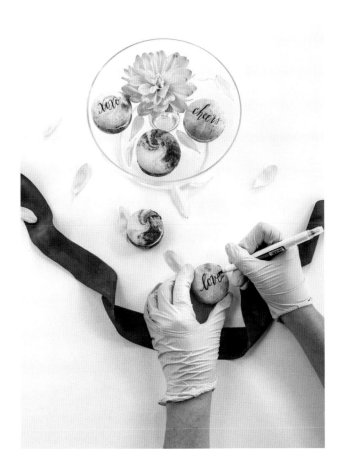

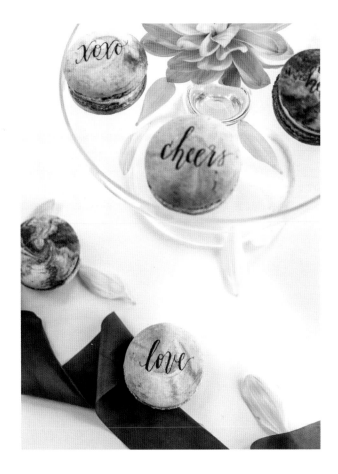

River Rock Place Cards

DIFFICULTY LEVEL: MODERATE-TO-HARD

Including river rocks in your wedding décor can add unexpected texture to your place settings while pointed-pen lettering keeps the look elevated overall. Smooth stones that are dark in color work best and can be sourced from craft stores, Etsy, or Amazon. Be sure to save your wider rocks for longer names, and if you are using these as escort cards, leave enough room for table numbers. (We recommend digits only on pieces of this size.)

Tools needed:

- River rocks large enough to accommodate names and/or table numbers

- All-purpose spray cleaner and paper towels

- Calligraphy pen, nib, and ink

TIP!

A nib that is already dull works best, as a new nib will dull immediately upon use on a hard surface such as this.

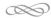

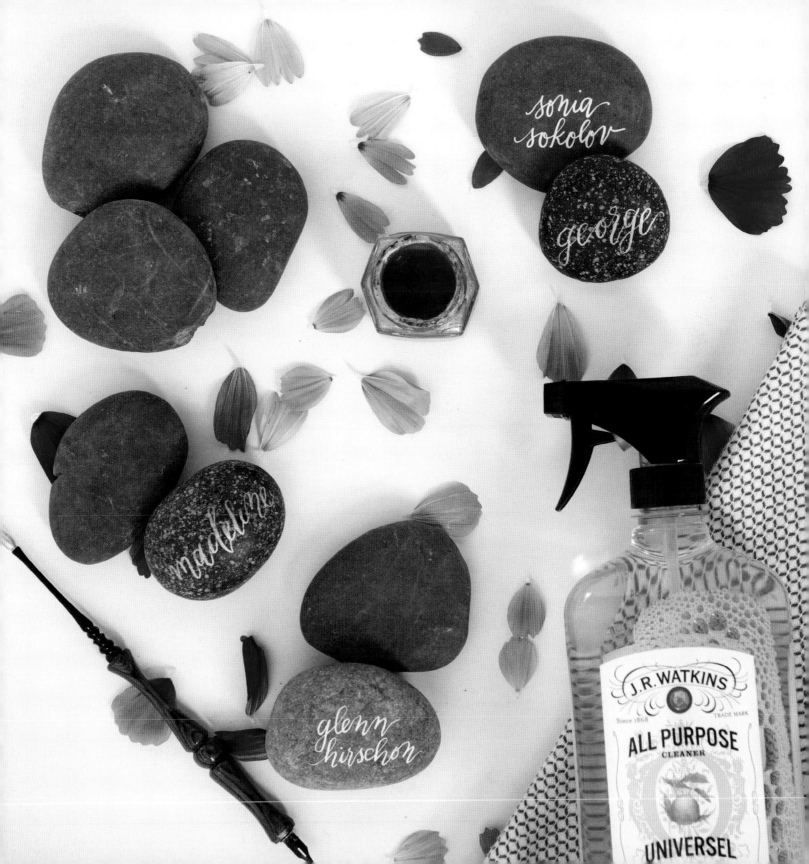

STEP 1: Prep each rock by wiping it down with a paper towel and an all-purpose cleaner such as Windex to remove any dust or natural grit.

STEP 2: Write each name while eyeballing the correct centering and making sure to avoid any pressure on your upstrokes. You should barely be grazing the surface of the rock—if you apply any downward pressure, the nib will catch and splatter ink or potentially break.

STEP 3: Double-check your finished rocks against your master list to check for spelling errors and make sure you've completed them all.

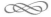 **TIP!**

Paint pens will work on rocks as well—just follow the steps from the oyster shell project to complete!

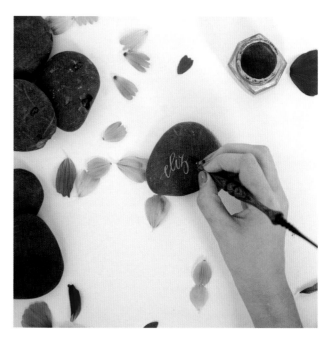

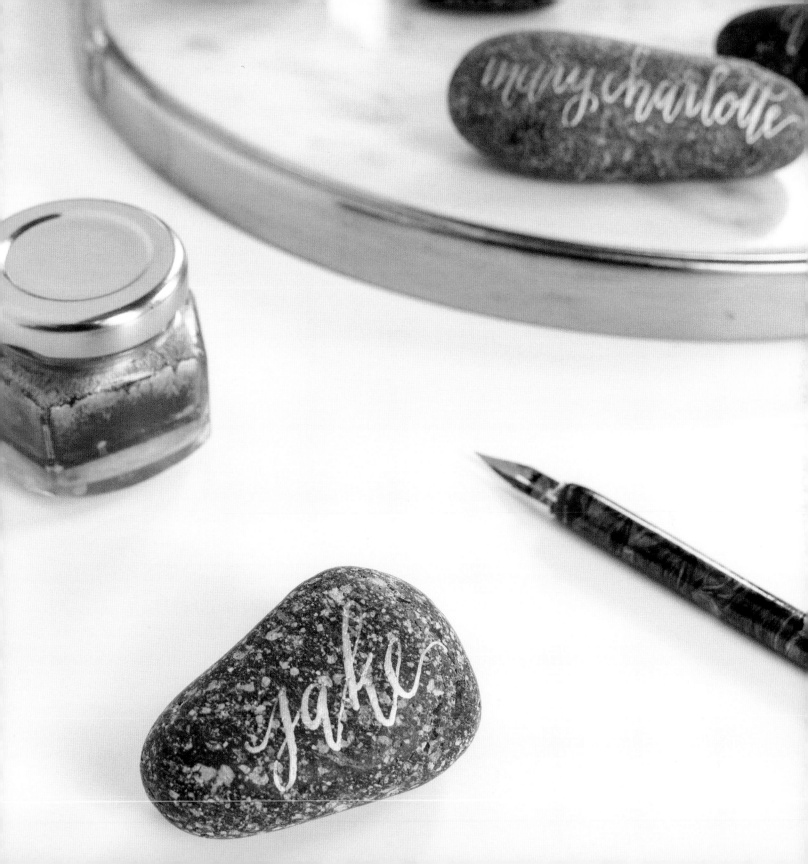

Wood Signs

Wood signage is all the rage at weddings, and since diverse looks can be achieved by using different scripts and shades of stain, this trend can be adjusted to fit pretty much any style or theme. The most common board size we use is 8" x 10", which can either be purchased precut at craft stores or custom cut out of plywood at home improvement stores. Keep in mind that this project can be a bit labor intensive, so be sure to allocate enough hours for drying time, creating the layout, and adhering to safety precautions in addition to the time needed for lettering.

Tools needed:

- Wood board in the size desired
- Wood stain
- Latex gloves
- Paint-mixing stick
- Sandpaper (or, for the particularly bold, a power sander)
- Clean, soft, cotton cloth (we buy packs at home improvement stores)
- Blue painter's tape
- Medium-point white paint pen (we prefer water-based Sharpie paint markers)
- Light colored pencil or sandstone marker
- Artist's eraser

together is our
is our

favorite
place to be

ANNAH & MASON

Oahu

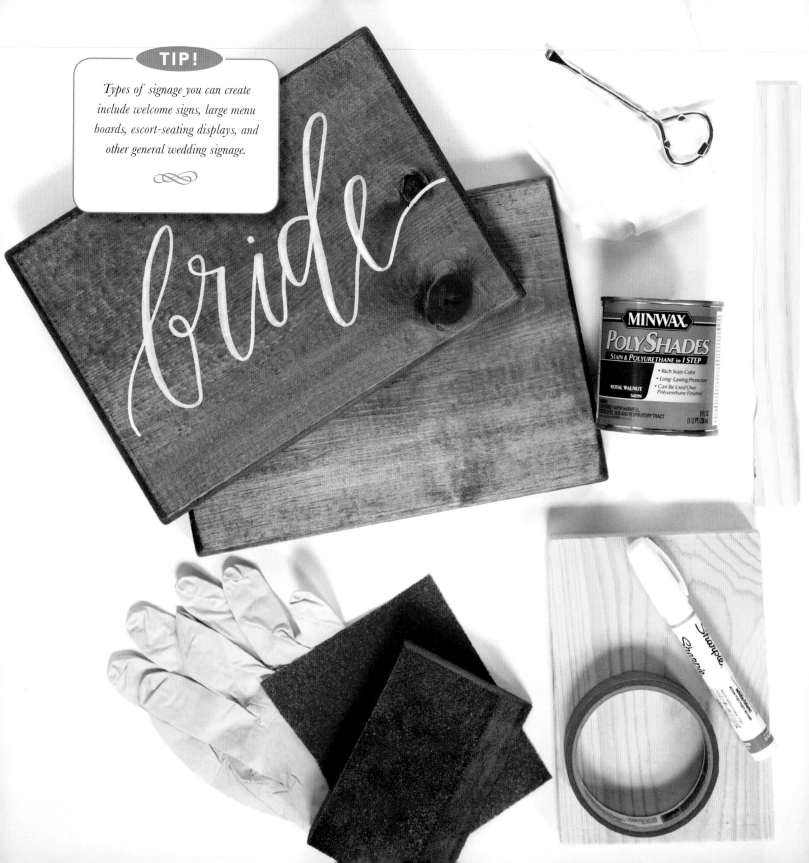

TIP!

Types of signage you can create include welcome signs, large menu boards, escort-seating displays, and other general wedding signage.

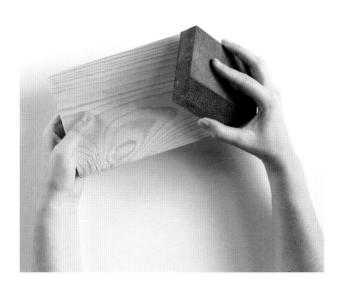

STEP 1: Prep your wood by thoroughly sanding the entire surface, including sides, edges, and corners. (You don't *have* to sand the backside, but we do.)

STEP 2: Wearing latex gloves, open the can of stain and thoroughly mix it with a paint-mixing stick or other stirring utensil. Dip the cloth into the stain, and smudge stain evenly over the surface of the wood.

STEP 3: Leave your board to completely dry. (We let our boards dry at least overnight, usually longer.) If you are in a rainy or wet climate, you may want to allow a full week for your board to dry, so be sure to prep well in advance. This is a very important step and could mean the difference between lettering with crisp, sharp edges, and lettering that bleeds and feathers. *Your stain must absolutely be fully dried.*

STEP 4: Once you have allowed adequate time for the stain to dry, physically touch the board to determine if it feels tacky or damp. Again, if it is not 100 percent dried, allow for more drying time.

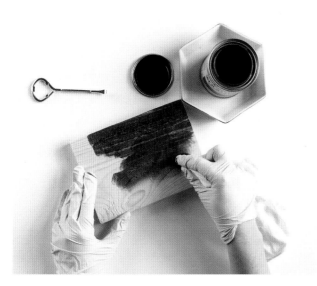

TIP!

We like to stain the backside first, let it dry, turn it over, and then stain the front, applying only a single coat to the board.

STEP 5: Measure out the lines for your lettering on the board. It can be helpful to draw a true-to-size sketch on a piece of paper or even lightly pencil the words onto the board before you begin to write.

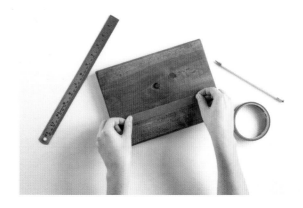

STEP 6: Place blue painter's tape to mark where your writing lines will be.

STEP 7: Using the paint marker, write out your wording in a monoline first, then go back and fill in the areas that need thickening (hint: these will always be your downstrokes). Let it dry before doing anything else.

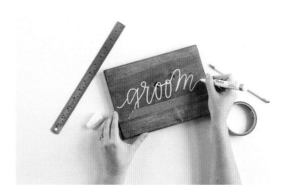

STEP 8: Erase any pencil marks and/or remove painter's tape from finished sign.

TIP!

Don't worry if you make a mistake—you can sand the area with the error thoroughly, restain it, allow it to dry, and touch up with the paint marker as needed.

In Closing

We are so glad that you have taken an interest in exploring the art of modern calligraphy and its applications to weddings and other celebrations. The possibilities for both learning and creating are truly endless.

We hope that this book has served as a starting point to thinking about the many ways that this art form can be put to use, that the introduction to pointed-pen has potentially sparked an interest in learning even more through workshops, starter kits, and additional practice, and that the practical applications shared leave you inspired to try your own hand at new creative projects.

While the art of both pointed-pen and lettering can take years of practice, and you will always be growing with the art, it is helpful to remember that your work does not need to be "perfect" in order to have fun with it and incorporate it into your own personal projects.

We wish you the best of luck in your calligraphy and lettering adventures!

Laura Hooper & Alyssa Hooper

Contributors

Thank you to our group of contributors who helped to bring the content of this book to life.

MARILYN OLIVEIRA: Story Editing

A writer and editor who has devoted more than half of her twenty-year career to the delightful category of weddings, Marilyn Oliveira is the cofounder of LuxElope.com, the website that launched the concept of luxury elopements within the travel and wedding industries. Prior to her turn as entrepreneur, Marilyn held pivotal editorial roles at WeddingChannel.com, *Inside Weddings* magazine, and Evite respectively, and has been tapped as an authority on weddings and celebrations by a variety of print, radio, and television outlets.

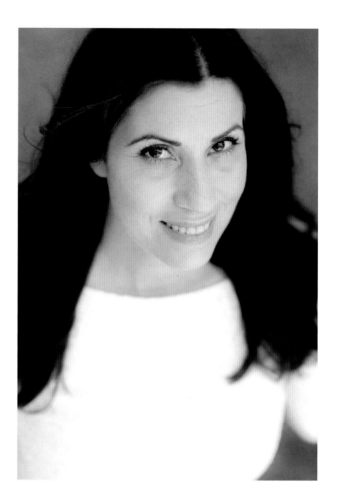

LAURYN PRATTES: Styling

Inspired by the world of fashion and interior design, Lauryn is serious about the true styling of an event, creating not just a party but also an experience. As one of the top planners in Washington, DC, Lauryn's work has been featured both nationally and locally in magazines such as *The Knot*, *Brides*, and *Weddings Unveiled*. Believing that the smallest details count the most—such as the perfect packaging for favors or sourcing the exact ribbon for a bridal bouquet—Lauryn spends countless hours working to style flawless events that leave guests inspired and intrigued.

ABBY JIU: Photography

Abby Jiu has had a passion for gorgeous imagery and creating art since before she can remember. Her style is the best of both worlds, using film cameras and digital cameras to catch the stolen glances, fits of laughter, and heartfelt emotions sprinkled among the ever-important beautiful details that make each couple's wedding day unique. She's received numerous accolades for her work, including being named one of *Martha Stewart Weddings'* Top Photographers and *Washingtonian* Editor's Pick. Her work can be seen on the pages of *Brides*, *Martha Stewart Weddings*, *The Knot*, *Southern Weddings*, *Washingtonian Bride & Groom*, *Southern Living Weddings*, and many more.

ANNE KIM: Photography

Anne is based in the Washington, DC/Virginia area, but her bags are packed and ready to travel to wherever there is creativity happening. Anne's love for photography goes much deeper than fitting into one category. Her images are greatly inspired by the creative environment and the roots of the East Coast and modern minimalistic aesthetic. On most days, she is coffee shop hopping while on the lookout for all things black and white. She finds the most joy in building creative content with creative human beings. Her passion to capture the authenticity of a moment begins and ends with this: *"created by The Creator to create."*

LAUREN ANDERSON & RACHEL BRIDGWOOD OF SWEET ROOT VILLAGE: Floral Design

Sweet Root Village, located in Alexandria, Virginia, specializes in event floral design and editorial photography. Established in 2010, this group of ladies shares a passion for life and people as they create beautiful things. As a team, they value intentional relationships; count on being driven and resourceful; are passionate about interpreting beauty in the everyday; and believe in encouragement that empowers an entrepreneurial spirit.

Acknowledgements

There are many people to thank for the creation of this book, as well as for sharing our journey with this beautiful art form both before and after its publication.

from Laura

Thank you to my husband, Jeremy, for never once complaining about the amount of time spent in the studio, the endless conversations about "the business," and all the "calligraphy emergencies," as he likes to refer to them.

from Alyssa

Thank you to my fiancé, Jesse, for holding down the home front during our frequent calligraphy workshop travels; for accepting the small-business, entrepreneurial lifestyle (including excessive picture taking!); and for adventuring along with us.

Thank you to our friends and families, who have supported us every step of the way as we turned a single project for a single friend into dream careers for both of us.

Thank you to our support staff, past and present, who put as much love, energy, and passion into every order as we do. Our Uncle Rad, in particular, followed Laura to Virginia to continue managing the warehouse so that packing, shipping, and ordering never ceased during the transition, and we are extremely grateful.

Thank you to our in-house editor at Skyhorse Publishing, Jesse McHugh, for his encouragement and guidance during the process of writing this book.

Thank you to the planners and designers who invite us to turn their creative (and often crazy!) ideas into reality, and push us beyond the bounds of our own limited imaginations.

Thank you to the photographers who have captured everything along the way, so that even the tiniest of details have not been overlooked.

Thank you to our clients—past, present, and future—who trust us with the most important day of their lives (so far!). We are humbled to play a role in your events.

Lastly, thank you to our calligraphy colleagues and students: It is an honor to keep this amazing art form alive with you.

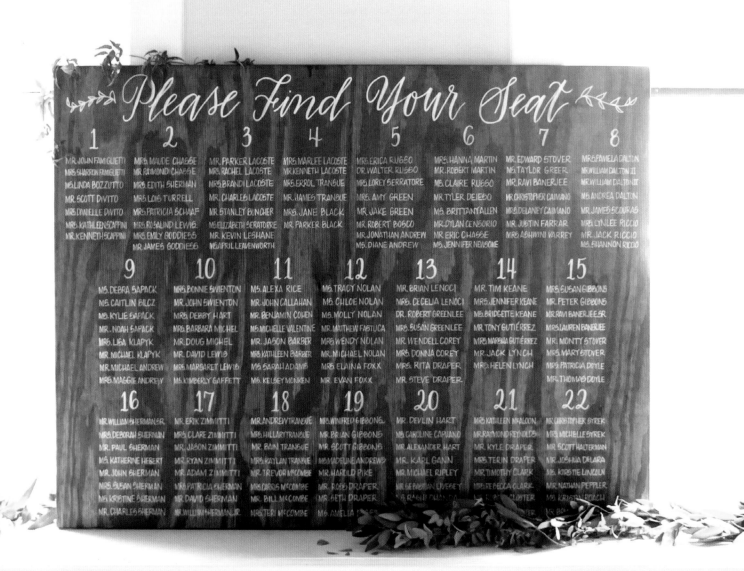

Glossary of Calligraphic Terms

A

APEX the pointed tip of a letter, as in the tip of the letter A

ASCENDER the upper stems of lowercase letters, including b, d, f, h, k, and l

B

BASE end of the nib, opposite the tip, that fits into the flange or pen holder

BASELINE the line in which all your letter bodies are sitting

BOUNCE letters that don't sit on the same baseline, often seen in modern lettering styles

BOWL strokes of a letter that form a "counter," such as in a, b, d, and g

BRANCHING where an upstroke branches out from the downstroke/stem of a letter, such as on h, m, and n

C

COUNTER a fully or partially enclosed space within a letter

CROSSBAR a horizontal stroke on a letter, including H or t

D

DESCENDER the lower stem that drops below the baseline on lowercase letters such as f, g, j, p, q, y, and z

DOWNSTROKE a stroke drawn in a downward motion

DRILLS practice patterns that develop brain and muscle memory as well as help to warm up the hand for writing

DUCTUS the sequence of strokes that together form a letter

E

EXEMPLAR a perfect model of an alphabet to use in the study of a calligraphic hand

EXIT STROKE a stroke that ends a letter

F

FLANGE portion offset from the staff of the pen holder itself, often made of brass or plastic, that holds the nib

FLOURISH embellishment added to the main structure of a letter used for decorative purposes

G

GOUACHE an opaque watercolor paint, often used to mix custom ink colors

GRIP the portion of the pen holder that is grasped

GUM ARABIC a thickening agent used to change the composition of ink so it sits on top of the paper material rather than bleeding or feathering out

H

HAIRLINE a fine line formed on the upstroke

HAND (CALLIGRAPHIC HAND) a script or writing style done by hand, not to be confused with typestyles on the computer, which are called *fonts*

HEFT the thickness of shaded strokes

I

INK THICKENER see *Gum Arabic*

INTERLETTER SPACE the space between two letters, referred to in typography as *kerning*

INTERWORD SPACE the space between two words

K

KERNING see *interletter space*

L

LEAD-IN STROKE the stroke that begins a letter

LEADING the space between baselines of successive lines, also referred to as *interlinear space*

LIGATURE connections between two letters formed by hairline strokes

M

MAJUSCULE capital letters

MINUSCULE lowercase letters

N

NIB the metal, detachable piece of the pen that makes contact with the paper

NIB ID identifying markers indicating the brand and size of each nib that can be found stamped on the body (or *shank*); also referred to as *imprint*

O

OBLIQUE PEN HOLDER calligraphy pen holder fitted with a flange in which the nib sits at an offset angle, making it easier to achieve the thick lines characteristic of pointed-pen calligraphy

P

PEN HOLDER the actual holder in which the nib is placed; can be oblique or straight, and is often made of plastic, wood, or metal

R

RAILROADING writing with the nib when it has little-to-no ink left, which often results in two very fine lines on the downstroke with no ink in-between

RESERVOIR the space beneath the vent of the nib where the ink sits after dipping and while writing; must be continuously refilled by redipping after ink has run out

S

SHADE the thick part of the downstroke created by applying pressure to the tines

SHANK the body of the nib

SHOULDER where the tines meet the body of the nib

SLANT the slope of a letter

STEM the vertical line that is the foundation of the letter's form

T

TERMINAL the start and end point to a stroke

TINES the two sides of the nib on either side of the slit that split when pressure is applied to allow more ink to flow

TIP point of the nib that makes contact with the paper/writing surface

U

UPSTROKE a stroke drawn in an upward motion, often referred to as a *hairline*

V

VENT hole in the top of the nib that draws in air so ink can flow smoothly

W

WEIGHT the height and size of a letter as compared to the size of the writing tool/nib you are using

X

X-HEIGHT the height of the lowercased letters' bodies